A–Z

OF

LLANDUDNO

PLACES – PEOPLE – HISTORY

Peter Johnson

AMBERLEY

*For Valerie, with love, for help and support so generously
shared during the writing of this book.*

First published 2018

Amberley Publishing
The Hill, Stroud, Gloucestershire, GL5 4EP
www.amberley-books.com

Copyright © Peter Johnson, 2018

The right of Peter Johnson to be identified as
the Author of this work has been asserted in
accordance with the Copyrights, Designs and
Patents Act 1988.

ISBN 978 1 4456 7502 2 (print)
ISBN 978 1 4456 7503 9 (ebook)

British Library Cataloguing in Publication Data.
A catalogue record for this book is available
from the British Library.

Origination by Amberley Publishing.
Printed in Great Britain.

Contents

Introduction

A–Z of Llandudno presents an alphabetically arranged stroll through the highways and some little-known byways of the town's past, meeting a number of colourful characters, unlikely and strange events and other curious matters along the way. Natural features are also included, setting the town and its hinterland in context. The aim is to portray the range and variety of Llandudno's inimitable features.

As with any enterprise based on the alphabet, certain letters, unsurprisingly, contain more entries than others. Each essay is self-contained so they may be read either in sequence or randomly. Some encompass overarching and interlocking themes, but these can be approached from any direction. However, if the author may make a suggestion, perhaps the first entry sets the scene for all the others.

Peter Johnson

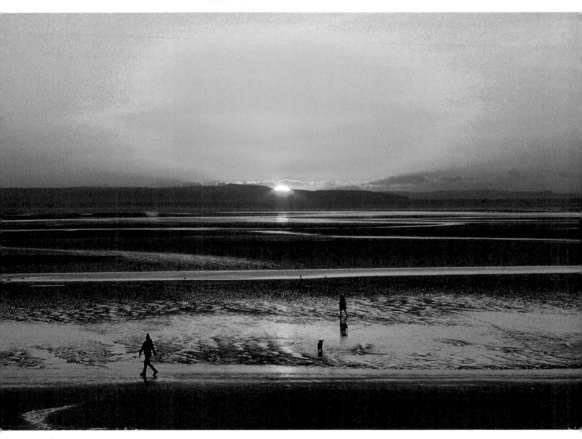

Sunset over Anglesey from West Shore at low tide, March 2018.

Approaching Llandudno

Travelling from the east along the coast, the last settlement passed through before ascending the Little Orme is Penrhyn Bay. The dual carriageway running up ahead was not always as it is today. From 1907 to 1956 trams on the Llandudno & Colwyn Bay Electric Railway ran along the upper lane while horse-drawn and motor vehicles travelled on the lower. Towards the highest point before the road begins its descent a large sign welcomes visitors to Llandudno.

The way winds down and passes Craigside Inn, formerly an eighteenth-century farmhouse, and the whole of Llandudno and its bay comes into view. Far to the left on the Conwy estuary lies West Shore. Looking along the promenade from this vantage point, it seems as if the further we go along it the earlier the history that is presented. The road passes through the relatively new residential area of Craigside. Now almost at sea-level, it skirts along the bottom of Bodafon Fields where the National Eisteddfod pavilion of 1963 was erected and nowadays an annual transport festival is held. Craig-y-Don follows next. This area has a history and land ownership pattern separate from Llandudno and is a slightly later development. The roundabout just before Llandudno Sailing Club may be considered for practical purposes as the boundary between the two towns, although they merge one with the other.

The road now runs within the ancient parish of Llandudno and Victorian hotels and boarding houses – all built to strict guidelines – stretch along the shoreline towards the pier. St George's Hotel, the earliest of these, was completed in 1854. At the end

Illuminated at night, this greeting speaks for itself.

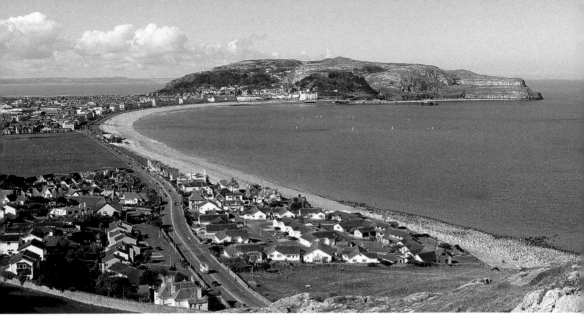

Craigside, Bodafon Fields, Craig-y-Don, Llandudno and the Great Orme from the Little Orme, with West Shore on Conwy Bay, top left.

of the promenade the road bears left and upwards, following Church Walks, one of town's older streets, which soon enters the original village of Llandudno. Looking straight ahead along the promenade the imposing Great Orme rises high above the sea. On this limestone headland resides a fantastic variety of wildlife among the sheep-cropped grassland and along its cliffs and crags. Also here evidence of life thousands of years ago can be found, including a Stone Age megalith and the world-renowned Bronze Age copper mines.

To paraphrase the sign greeting the traveller crossing over the Little Orme, welcome to Llandudno.

Edwin Arrowsmith and the Children's Special Service Mission

The Children's Special Service Mission began its work on North Shore on 26 August 1868, and Llandudno has held a special place in this society's history since that day. In the previous year Josiah Spiers had begun teaching children about the Bible at his home in Islington, then in 1868 while on holiday in Llandudno, he wrote 'God is Love' on the sands. Children began to gather round and he encouraged them to decorate the letters with seaweed and shells as he told them about the Bible and its teachings. Today the society he founded on Llandudno's beach is known as the Scripture Union – which operates in over 130 countries.

The society quickly began to attract like-minded members and it was not long before beach services were being held in forty seaside resorts across the country. One of its members had a long association with Llandudno: Edwin Arrowsmith (1848–1924). He began his work on Llandudno's beach and in Happy Valley in 1873 and held services here every summer for nine years. He also carried out charity work for other religious groups and for local social causes and individuals in distress, through holding a silver collection during his Happy Valley services.

6

Gabriel Williams was one of many small farmers in the area, holding 15 acres from Tŷ Rheiol near the Little Orme. Adversity struck in September 1879 when his only horse died due to a severe accident. Mr Williams was facing ruin as without this animal he could not continue farming. Edwin Arrowsmith made an appeal among his private friends to cover this loss and within a few days had handed over to Mr A. Evans, the manager of Messrs Pugh Jones & Company's bank in Llandudno, £7 1s (£7.05). Two years later the census shows that Mr Williams remained a farmer at Tŷ Rheiol, though there is no record of the horse he bought with the proceeds of this generosity.

Edwin Arrowsmith left Llandudno around 1882. After a spell in Scarborough, he returned in 1889. He was well received – a report indicates that 3,000 hymn sheets were given out at one of his services in Happy Valley and around 800 'attentive' children sat in a half-circle listening to the service. The following week he raised funds on behalf of a local convalescent home. He returned to Llandudno several times thereafter and held his last services here probably in 1905.

Edwin Arrowsmith is best remembered not for his good works in Llandudno but for being the father of Sir Edwin Porter Arrowsmith (1909–92), a politician who served in several parts of the Commonwealth, in particular as Governor of the Falkland Islands and the British Antarctic Territory. He was also a member of the Council of St Dunstan's for twenty-eight years, the charity that helps blind servicemen, now known as Blind Veterans UK. This charity offers their provision nationally, including at the former Lady Forester's Convalescence Home on Queen's Road in Craig-y-Don.

North Shore, where Josiah Spiers began his mission.

Inset: Edwin Arrowsmith, photograph by Slater, Llandudno, August 1905.

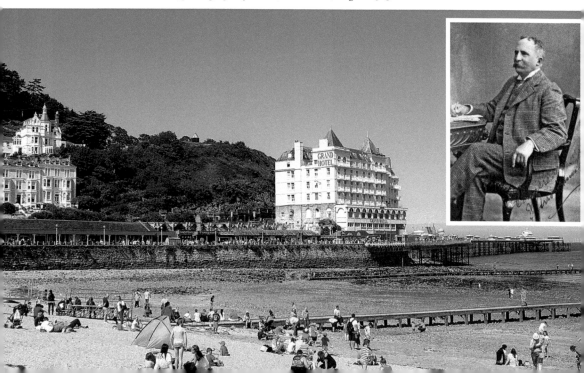

The Artillery School

London, the Home Counties and the south-east of England were particularly vulnerable to German bombing raids during the Second World War. More out-of-the-way places such as north Wales were considered less likely to be ravaged and much of the infrastructure of government and military training was relocated to these relatively safe areas. Colwyn Bay became the new centre of operations for the Ministry of Food. In 1940, Llandudno became home to various departments of the Inland Revenue – the Grand Hotel, the Imperial, the Ormescliffe and many other hotels, guest houses and private residences were requisitioned for their use.

The Royal Artillery's Coast Artillery School was established in September 1940 on the western flank of the Great Orme. This was a far less assailable location than their original base at Shoeburyness in Essex. The Great Orme possessed land that could be occupied for military purposes away from centres of population, yet close enough to town to provide accommodation and other facilities. The particular location of the school's firing range was chosen as target boats anchored in Conwy Bay could be directed by radio and a clear line of sight was presented for gunnery practice. Wireless and searchlight wings were subsequently added and at its peak over 700 men participated in operations at any one time. It closed after the end of hostilities in 1945. Today only scattered evidence of this once major and nationally important undertaking remains, though that which does has been protected since December 2010 by the historic buildings and ancient monuments body Cadw.

The former site of the Nissen huts, which stored ammunition shells.

Inset: Royal Artillery officers and other ranks pose for a photograph, probably in 1940–41.

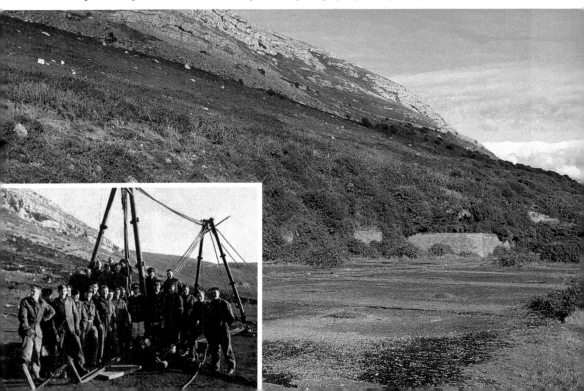

B

Beer – Brewing, Bottling and Labelling

Llandudno has its fair share of establishments where alcoholic beverages may be obtained and consumed, which should come as no surprise in a holiday resort. The King's Head on the Old Road is Llandudno's oldest surviving inn; records of it go back to the 1820s when it was also a venue for public meetings and other local affairs. It might be asked where its beer came from. In 1821, William Cobbett, although focussing on England, stated that outside of towns that possessed a 'public Brewhouse' much brewing took place in the home and this may have been the case on the Great Orme, being a profitable sideline for one or two households. Some public houses also brewed their own; while there is some evidence for this activity in Conwy none appears to survive for Llandudno. As the population of the country increased rapidly in the early 1800s, demand for the beverage grew. This thirst was quenched by obtaining large casks (barrels and hogsheads) from established breweries such as those based in Burton-on-Trent. These were shipped into Conwy and delivered to Llandudno either by boat or by horse and dray. In 1895, Worthington's agent for the district, J. C. Smallwood at the Blue Bell, Conwy, was the first to witness the arrival of ale from Burton-on-Trent, which had travelled via the Manchester Ship Canal. In later years beer also arrived by train. Once at the point of sale – public houses and inns – it was poured directly from the cask. The domestic market (off-sales) was serviced by small casks (pins) or occasionally earthenware flagons filled from a cask.

Bottled beer has its own history. The cost of glass was high and it was easily breakable. Furthermore, it would have required the breweries to invest in and build bottling plants. It took until around 1880 before they began bottling beer, but even then they did so by building or renting premises close to the point of sales to use as bottling stores and delivering beer to them by cask. Bulk beer could be brought from brewers at wholesale prices, so many enterprising grocers and beer agencies – as well as inns and hotels – would buy casks of Bass, Guinness and Worthington's and bottle it themselves with their own label. The Carlton on Mostyn Street was one such outlet in Llandudno. Dunphy's the grocer and Captain Lester, wine merchant, Mostyn Street, were others who had their own facilities for bottling beer. This was the norm up to the 1920s and sometimes beyond. The first mention of 'bottler' as a trade found in the census for Llandudno appears in 1881 and their enumeration over the decades was sometimes 'Bottler (Cellar man)', at others 'Bottler (Bottling Store)'.

As the twentieth century progressed the sale of bottled beers expanded considerably, a consequence of the availability of cheap glass bottles and by direct bottling at the brewery. In the twenty-first century brewing and bottling has 'come home' with the advent of local and microbreweries producing craft beers. Llandudno has two such enterprises, the Wild Horse Brewing Company and the Great Orme Brewery.

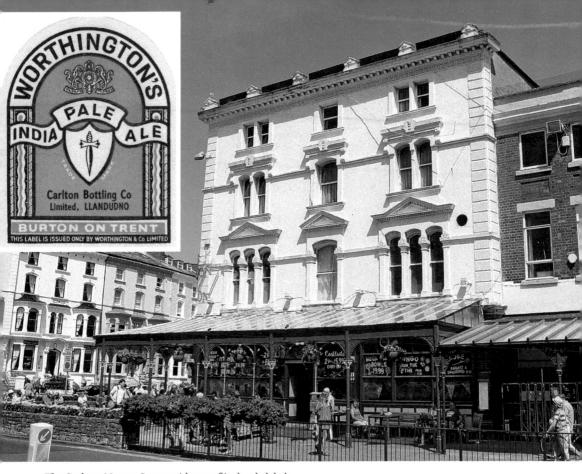

The Carlton, Mostyn Street, with one of its bottle labels.

Belle Vue Terrace

These private dwellings are situated on the steepest part of Tŷ Gwyn Road, the main route leading to the summit of the Great Orme. With a gradient of 1 in 4, motorists are advised to approach this stretch in first gear. A glass slide photograph dated 1889, though probably taken sometime before then, shows a scene of small-scale industrial activity, with a broken castellated wall enclosing an abandoned quarry. A decade or so later Belle Vue Terrace had been built and in 1903 the Great Orme's trams passed along this way to and from the summit. Within twenty years this part of old Llandudno had been transformed almost beyond recognition, a process that had been taking place throughout the area since the first hotels appeared on North Shore in the 1850s.

Taken in 1889 or earlier.

Taken in 2017.

Bell Pits and the 'Welsh California'

An extensive landscape of small pits and associated mounds comes into view soon after walking down the slope eastwards from the Summit Complex on the Great Orme. These are not natural features but the remains of surface mining for copper. Most of these pits date from the mid-nineteenth century though aerial photography suggests some earlier workings and a more complex industrial situation in Bryniau Poethion, an area of common land.

Gold had been discovered in California in 1848. The gold rush took off in 1849, hence the 300,000 or so who descended on this region of the soon-to-be state were known as 'forty-niners'. This stampede to find the precious metal and make oneself rich beyond imagination became internationally newsworthy – including in many local and regional newspapers in Wales. *The North Wales Chronicle* published columns of up-to-date bulletins and rumours under headings such as 'Latest News from California'.

The Great Orme did not lure a similar number of those seeking valuable metal, perhaps because copper was being pursued rather than gold and the headland does not cover quite the same extent as California. Nevertheless, 1849 witnessed an upsurge of mining activity of such intensity that the area became known as the 'Welsh California'. These miners operated in small, independent gangs and used primitive tools to dig a pit where they hoped copper-bearing ores would be found. Next to these pits are the spoil heaps where the debris was discarded. Some pits are quite shallow, others are surprisingly deep with the most extensive excavations so far discovered going down at least 400 feet below the surface and terminating in large caverns. A number of these caverns are interconnected suggesting mining activity on a scale not previously suspected. Yet at these levels the dangers of this primitive operation increased as flooding became a major hazard. Torrential rain in March 1993 caused some pits to

A landscape of surface copper mining.

collapse inwards, which gives an indication of the dangerous conditions these miners worked under. For those who survived and found the hidden treasure then riches lay ahead – though perhaps not as great as finding a seam of gold.

John Bright MP

The *Halifax Courier* of 19 June 1886 published a column describing 'A Sunday in North Wales' focussing on Llandudno and St Tudno's Church in particular. The correspondent describes a marble headstone in the graveyard that surrounds the church: 'In loving remembrance of Leonard Bright who died at Llandudno, November 8th, 1864, aged nearly six years.' The report continues, 'Leonard, a short time before his death, expressed a desire to be interred in St Tudno's Churchyard.' The young boy died of scarlet fever, a scourge of a disease and a common cause of death among children. During the middle of the previous month the *North Wales Chronicle* had welcomed John Bright MP and his wife and seven children to Llandudno (Leonard was the youngest). He first visited Llandudno in the mid-1850s and after the sad event of 1864 he would return every year thereafter to visit the grave of his little boy.

Llandudno Board School, now housing Conwy Archive Service.

Inset: John Bright, carte de visite by Oglesby, Llandudno.

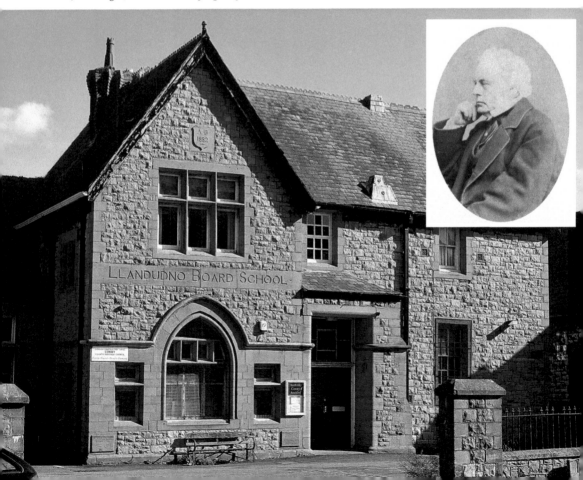

John Bright (1811–89), a radical politician considered one of the finest orators of the nineteenth century, was first elected as MP in 1843. He coined the well-known phrase 'the mother of parliaments', though the full version was actually 'England is the mother of parliaments'. He was a member of Liberal cabinets as President of the Board of Trade and as Chancellor of the Duchy of Lancaster. In March of that fateful year – 1864 – President Abraham Lincoln wrote of 'the esteem held by the United States of America for the high character and steady friendship of the said John Bright'. This related to the case of a twenty-year-old British man who had been convicted of aiding the Confederate cause. John Bright's intervention secured the man's release and return to Britain.

He was so regular a visitor to Llandudno that he became attentive to local affairs and would often be seen riding his horse, stopping and chatting with people along the way. In 1881, he placed a memorial stone initiating the building of Llandudno Board School in Lloyd Street. The establishment of the John Bright Scholarship was also proposed at that time, for which local people donated funds. By 1895, six years after his death, plans were put forward to build a new intermediate school – John Bright County School – with costs covered by capital held by this fund. It opened in temporary premises – now the Risboro Hotel – the following year. Permanent purpose-built premises were erected on Oxford Road by 1907 and these were officially opened that September by the American Ambassador, Whitelaw Reid. The school remained on this site until 2004 when Ysgol John Bright was relocated to new buildings and grounds on Maesdu Road. He is also remembered in the naming of Bright Terrace, a row of properties in Lloyd Street.

Bronze Age Copper Mines

The Bronze Age Copper Mines on the Great Orme are an archaeological site of international importance, yet for centuries their existence was unrecognised. Close to Pyllau Farm on the Great Orme copper mining had sporadically operated from 1692, though it was not until the nineteenth century that it became a major industrial operation. Two mines were in place in this area: the Old Mine and the New Mine. Extraction of copper ore reached a peak by the 1830s and the mines were the hamlet's major employers. By the 1850s flooding and better employment opportunities elsewhere were among factors that led to their closure. A lingering backdrop of spoil heaps and industrial dereliction remained from their demise.

Although this ground was a minor curiosity, a proposal was put forward in 1987 to landscape the area and turn it into a car park. Before this could be carried out an underground survey was undertaken to assess the stability of the land. Archaeologists, mining engineers and members of the Great Orme Exploration Society descended first into nineteenth-century workings. Unexpectedly, they soon discovered a complex network of ancient passages and caverns along with bone tools and other prehistoric mining equipment. Scientific analysis of these relics disclosed that they dated from the Bronze Age. Opencast mining probably began on this site around 2000 BC. Once these ores were depleted underground tunnels were opened up around 1860 BC, and by 600 BC, when the mines were abandoned, a labyrinth of over 5 miles of tunnels and caverns had been excavated. At least, that is the extent so far discovered – further exploration will add to this. In its time the mine was one of the world's largest industrial operations and had a clientele extending into northern Europe. It has been

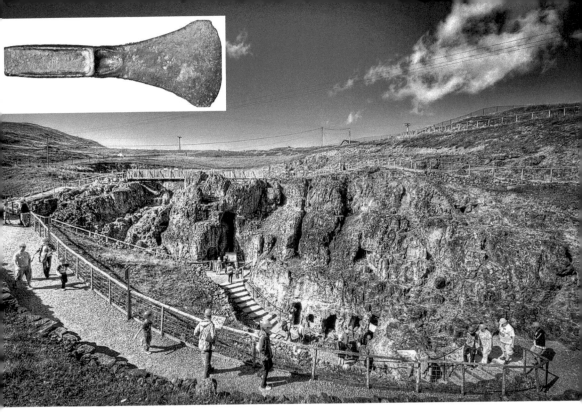

Visiting the mines.

Inset: Axe found on the Little Orme. (Courtesy of Bronze Age Copper Mines Ltd)

estimated that sufficient copper to manufacture around 4 million axes could have been mined, such as the one dating to around 1450 BC found on the Little Orme.

Since 1987, and overseen from 1990 by the Bronze Age Copper Mines Ltd, the site has been stripped of its nineteenth-century dereliction and the ancient workings revealed. Visitors can now discover the mines and safely walk along ancient passageways. One highlight of this tour is the 3,500-year-old Grand Cavern, an astonishing mining achievement for that period. The visitor centre, extended in 2014, displays life in those times along with a selection of copper artefacts and tools from this mine, one of the top geoscience sites in the country.

Buffalo Bill's Wild West

The American Wild West rode into north Wales on three long trains, comprising sixty carriages of great size on Monday 2 May 1904. Buffalo Bill's Wild West and Congress of Rough Riders of the World arrived in Llandudno at 2 a.m.

Buffalo Bill – real name William Frederick Cody (1846–1917) – had a colourful life on the American frontier as a Pony Express rider, a scout for General Sherman, a Buffalo hunter for Kansas Pacific Railroad (where he acquired his nickname), and then in 1868 as chief of scouts for the 5th Cavalry. His fame led penny dreadful writer Ned Buntline to publish *Buffalo Bill, King of the Border Men* – this was the first of 550 titles about his heroics. By 1872 he was a member of Buntline's show 'The Scouts of the Prairies'. 'Wild Bill' Hickok was invited to join the group a year later for the new

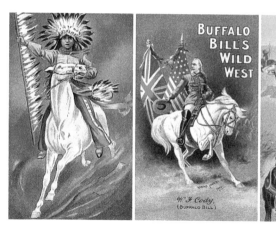

Promotional postcards issued for the British tour, 1904.

show, 'Scouts of the Plains', but left within a few months as the brave frontiersman often hid behind scenery when he should have been performing. Over the next few years Cody ran his own extravaganza, 'Buffalo Bill's Combination', though remained a scout on the plains. He followed this with 'Buffalo Bill's Wild West', a circus-like attraction presenting a rather romantic view of cowboys and 'Indians'. When it arrived in London in 1887, thousands lined the streets as the showman made his way to Earl's Court. On opening night it played to 28,000 spectators. He returned to Britain in 1891, then again in 1902 to 1904.

The company pitched tents on the council field on Conway Road, not far from the train station. Today this area is the retail park, Parc Llandudno. If the residents and visitors of Llandudno had been awestruck four years earlier when Barnum and Bailey's Circus camped here we might imagine their reaction to beholding nearly 700 horses and their riders – including cowboys, male and female 'Indians', Cossacks, Mexicans, Arabs, Japanese, Roosevelt's Rough Riders, United States Artillery, and English Lancers recently returned from the Boer War – and Native Americans erecting tepees. Enormous tents, two of which were 120 by 90-foot stabling blocks, another the 414 by 180-foot arena, and all the other elements of this encampment finally emerged in the gloom of that day of inclement weather by 9.30 a.m.

The show began at 2 p.m. with 'The Grand Entry'. The first to burst into the arena at breakneck speed were 'gaudily-bedecked' riders from the Great Sioux Nation, followed by other Native Americans, then in turn by groups of 'Rough Riders of the World'. The noisy and colourful grand parade was completed by the United States cavalry led by Colonel Cody. The show continued with horsemanship, sharpshooting, Pony Express riders, wagon trains, and military exercises. A central part of the show staged an enactment of General Custer's Last Stand at the Battle of Little Big Horn in 1876, which included Sitting Bull's son as a member of the Sioux forces. After many other spectacles the show was brought to a close with an 'attack' on the Deadwood Stagecoach.

What was also remarkable about this show is that they took only Sundays as rest days and toured the length of Wales, Scotland and England in 1904, from 25 April to 21 October, travelling, unpacking, performing and then packing it all again virtually every day.

Alfred Randal Catherall

St George's Hotel was the first to be built on the seafront and was owned by the Davies family from its construction in 1854 until 1977 when it was bought by Michael Forte. Soon after acquiring the hotel he commissioned Arthur Randal Catherall (1926–2013) to produce thirty-three large-scale panels of local scenes and places from further afield. These were completed in two years – 1979 and 1980 – and twenty-eight are on display in the hotel.

Alfred Catherall hailed from Chester and spent some years living in its oldest surviving house, Tudor House. In 1961 he held an exhibition of art and sculpture there, which included two by L. S. Lowry. As well as being a fine art and antiques dealer, he was a prolific painter and held exhibitions in the Netherlands, Germany and Paris. His work continues to be exhibited, gracing the walls of St George's Hotel.

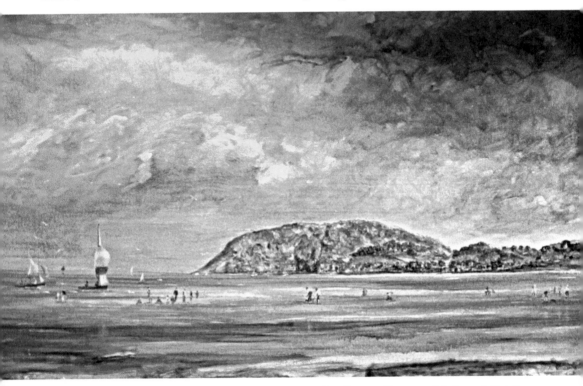

North Shore Beach and Little Orme with Sail Boats by A. R. Catherall, 1980. (Courtesy of St George's Hotel)

Church Walks

The copper mines on the Great Orme were approaching their maximum output in the 1830s and the little village of Llandudno was slowly growing and evolving. By the 1840s any new development had to encroach on the lower lands beneath the old village. St George's Church was built by 1840 on what would become Church Walks and a short distance away St George's National School opened for its first scholars in 1846.

The 1841 census for the 'Upper Township' lists no named streets, the enumerator seemingly choosing the easiest route from one isolated dwelling or short row of cottages to the next. George Brookes, publican, and his family resided at Victoria Inn. A decade later, in 1851, other buildings have been erected close to the inn. Though these were still few, the line of the road listed as Church Street in the census can be recognised. In 1854, No. 70 Church Walks (now the Capri Guest House) was designated the offices of the Board of Improvement Commissioners. That same year Thomas Williams opened the imposing Italian Warehouse, essentially a large department store, facing down Mostyn Street. This is now the Empire Hotel. Within a few short years Church Walks had become a major thoroughfare and the emerging town's administrative and retail centre. It was also attracting visitors to its guest houses and villas – as elsewhere in town the focus was very much towards tourism. The street's retail and administrative functions slowly declined as the town developed along other streets; the welcoming of visitors continued undiminished.

St George's Church.

Inset: The restored 1853 extension of St George's National School.

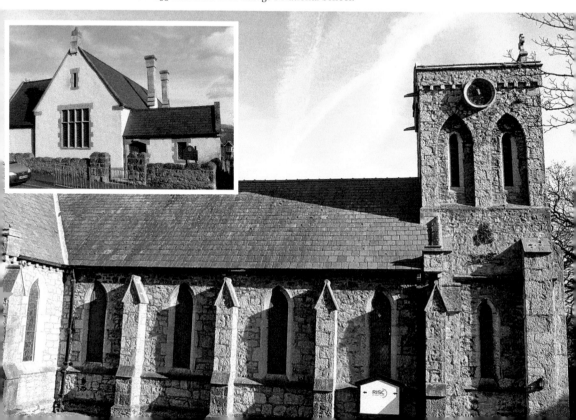

Guest houses along Church Walks.

Conducting the Orchestra and BBC Radio Broadcasts

Llandudno's theatres have been graced by many a fine musical talent and not only of the popular music variety. Before closing in 1986, the Astra (formerly the Odeon, originally the Winter Gardens) presented performances by the Welsh National Opera and the Vienna Festival Ballet. This appeared to signal the end of a tradition for staging high-level classical music after more than 100 years.

In 1887, Jules Rivière (1819–1900) began conducting his orchestra of thirty-six players in the Pier Pavilion. A piece often performed was 'Massenet's Grand Heroic March'. A conductor who would later become well known for 'The Proms', Henry Wood (1869–1944) was present at one of Rivière's concerts and was shocked to see him conduct the orchestra seated and facing the audience. Following disagreements with the management, Rivière left in 1891 and moved further along North Shore to Craig-y-Don and the newly built Rivière's Concert Hall. After a few less-than-successful musical directors, Arthur Payne, the leader of the Pavilion Orchestra, took over the duties of conductor by 1900. He was also the leader of Wood's Promenade Orchestra from 1896 to 1902. Although initially very successful, by 1925 the Pier Company considered that a new direction was needed.

Two individuals who became world famous were soon to be involved with this orchestra. Malcolm Sargent (1895–1967, knighted in 1947) became its conductor in 1926 for two seasons. Initially somewhat unwelcome in Llandudno, he won over his audiences and began to present more ambitious shows, which included symphonic works. The orchestra subsequently played under the baton of John Bridge for a few seasons, then under George Cathie who often presented new works by British composers.

Adrian Boult (1889–1983, knighted in 1937) began his conducting career with the Royal Opera House and by 1930 had been appointed as director of music for the BBC, establishing the BBC Symphony Orchestra. Cathie's work with the Pavilion Orchestra came to his attention and he arranged radio broadcasts from the Pavilion. He was welcomed as its guest conductor on 26 August 1932. Classical music in Llandudno was now a major phenomenon. It lasted only until 1935 at the Pavilion as the company again decided that a change was needed and variety acts and dancing came to dominate with performances from stars such as George Formby, Ted Ray and Arthur Askey.

Right: Jules Rivière, 1891.

Below: Sir Malcom Sargent in 1927, with the Pier Pavilion and Grand Hotel in the background. (© National Portrait Gallery)

BBC radio broadcasts from Llandudno did not become a thing of the past at that time; they moved across town to the Odeon and talented organist P. Allender Fryer. Since his teens he had been a noted musician and choir master, and in 1923 was accompanist to the winning male-voice choir in the National Eisteddfod. He took up cinema organ work at the Park Hall Cinema, Cardiff, from where he broadcast in 1929. By 1937 he was broadcasting organ recitals from the Odeon where he played pieces such as 'Llandudno Blue Rhapsody' and 'A Selection of Welsh Marches'.

Towards the turn of the century the tradition for presenting top-rate classical music in Llandudno reappeared and today Venue Cymru hosts concerts given by internationally renowned conductors, soloists and orchestras, opera and ballet companies.

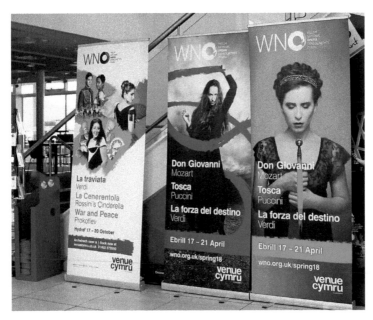

Welsh National Opera
in Venue Cymru, 2018.
(Courtesy of Venue
Cymru)

Craig-y-Don

The backdrop to Craig-y-Don and Bodafon Fields is an inland extension of the limestone ridge of which the Little Orme is part, curving around and separating this suburb of Llandudno from the lands to the east and the south. As on the Ormes, this environment was favoured by the region's earliest inhabitants. Pant-y-Wennol Cave on the ridge above Bodafon Farm was excavated in the 1970s and found to contain evidence for its use as a place of shelter for many species, including reindeer, red and roe deer and a woolly rhinoceros towards the end of the last ice age. Our species became associated with this cave in the late Mesolithic (Middle Stone Age). Dating from 6000 BC, this period saw the production of extremely small and fine microliths – tools made usually from flint – and is associated with small bands of hunter-gatherers establishing settlements in both upland and lowland areas, migrating between them as the seasons changed. This period it is not well represented in north Wales due to sea-level rises destroying evidence over the land they would have roamed. The larger share of artefacts discovered in the cave were from the Neolithic period: the remains of four adults and two children, pottery fragments, stone tools, a bone needle and a stone that may have been used as a weight in fishing nets. A number of stray finds from prehistoric times and into the Roman period have been made hereabouts, many of which raise more questions than they give answers.

The later history of this area centres near the top of Nant-y-Gamar Road, before the ridge descends on its south-facing aspect towards Gloddaeth Hall, originally home to members of the Mostyn family (since around 1500). Sometime between 1617 and 1642 Sir Thomas Mostyn built a windmill on the ridge, overlooking Llandudno Bay. It is shown on a map of 1748 as a landmark to guide mariners and was taken over, probably in a derelict state, during the time of the Napoleonic Wars (1803–15) for use

as a warning beacon if invasion threatened. Fifty or so years later it had become a private dwelling and it remains so today. In the late nineteenth century, predating the major quarrying operations on the Little Orme, beds of white china clay were excavated in an area at the top of Nant-y-Gamar Road and loaded onto beached merchant vessels on the shore.

This road marks a severe break between the built-up area of Craig-y-Don and Bodafon Fields – even the mighty Mostyn Avenue (a continuation of Mostyn Street, which starts at the other end of Llandudno) comes to a dead stop and all traffic has to turn left or right. The one exception to this was the continuation of the route for the tram service to Colwyn Bay (in use 1907 to 1956), which had its tracks laid straight across the field.

In the aftermath of the Enclosure Award of 1848, Thomas Peers Williams was granted 28 acres of land in Llandudno. He owned Marl Hall, situated a little way from the other great Mostyn residence, Bodysgallen Hall, 3 and a half miles south of Llandudno. Thomas Williams named his area of ground Craig-y-Don after his home in Beaumaris on Anglesey. The first building to be erected in this new development was Ascot House in the 1870s, on what is now Carmen Sylva Road. It stood isolated until after 1884, the year Craig-y-Don estate sold the freeholds to 2,210 acres of land. Bodafon Fields were retained by Mostyn estate. Houses, hotels and facilities such as shops and tennis courts were soon in place. The architecture of Craig-y-Don resembles that of Llandudno though being a later development its buildings project a certain contrast. Much of the construction work was directed at establishing residential areas with guest houses and hotels gracing the seafront and streets leading to the promenade. The largest buildings in the suburb are St Paul's Church, which opened in 1895 on Mostyn Avenue, and Blind Veteran's UK Centre, formerly Lady Forester's Convalescent Home, established in 1904 on Queen's Road. The original Washington Hotel on the seaward end of Clarence Road protruded out towards the promenade by such as extent it became a danger to traffic and was rebuilt in 1924, a time when new architectural ideas were being practiced in Llandudno.

Craig-y-Don and Bodafon Fields with the limestone ridge behind.

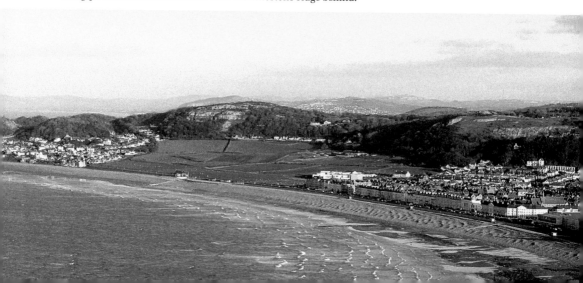

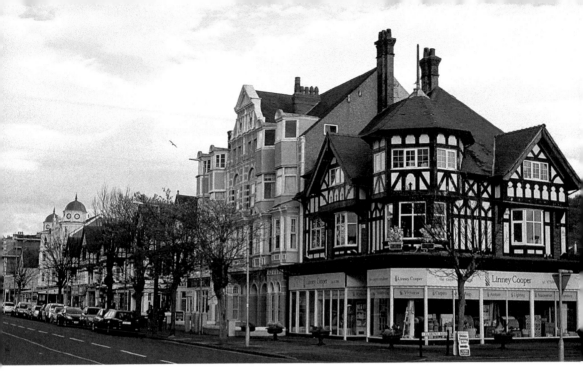

Above: Mostyn Avenue.

Left: The Washington, now a restaurant.

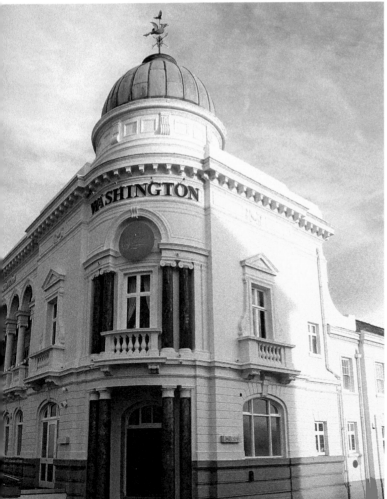

D

Donkeys and Cavalcades

Donkeys were introduced into Britain by the Romans. These beasts of burden had transported goods and people on their backs and pulled carts in Mediterranean countries for millennia. They probably reached Llandudno after the Romans had invaded north Wales and built their fort further down the Conwy valley at Caerhun. From this time until well into the twentieth century this species – along with its cousin, the horse – carried out its traditional duties. For centuries they were the only form of local transport for the carrying of goods and raw materials and for pulling gigs and carriages.

With the rise of mass tourism in the 1850s donkeys soon began to take on an old role in a new environment. They were the ideal creature to amuse holidaying urban-dwellers on short trots along the beach. The rides were offered towards the western end of the shore, close to the area where the first hotels on the seafront had been built, and they have trotted to and fro along this stretch of sand to this day.

As the animals were a valuable asset – indeed, sometimes the only source of someone's income – they were generally well looked after, but this might not always have been the case. So as to ensure the animals' well-being, a number of stratagem were employed. For example, in 1883 a visitor from Birmingham in conjunction with the local RSPCA invited around forty of the 'donkey boys' to a sit down meal at the Cocoa House and offered prizes of £3 for the best cared for donkey and the best behaved attendant. By the turn of the nineteenth century the RSPCA began organising 'Donkey Parades' on the beach to judge the 'donkeys in the best condition and most kindly treated'. Concerns about the well-being of these animals were raised again in 2010. On this occasion guidelines issued by the Donkey Sanctuary quickly resolved these anxieties and young equestrians can continue to saunter happily across the beach on the back of one of these docile creatures.

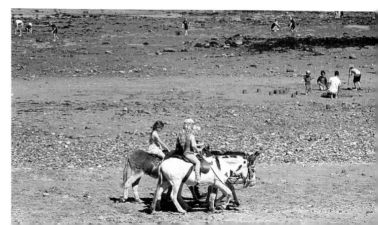

Donkey rides, one of the many pleasures of Llandudno's North Shore.

A rather odd amusement had become fashionable in Llandudno by 1906. A large group from a hotel or boarding house hired as many donkeys as they could then 'dressed up' and 'rode' around town on them. This activity was politely described as a 'cavalcade'. It might be too fanciful to wonder whether these riders were imitating Buffalo Bill's Wild West show of 1904. The RSPCA brought this matter to the police who prosecuted one group of revellers, or, to be more precise, they prosecuted those who hired out the animals. The case was dismissed and the craze appears to have subsided or, maybe, was no longer newsworthy.

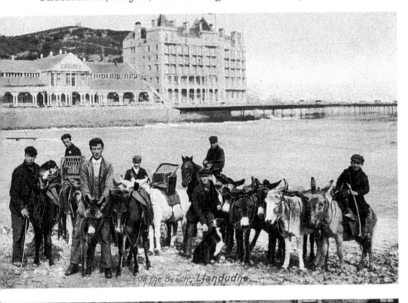

Donkeys, dogs and donkey boys (probably prosecuted) in 1906.

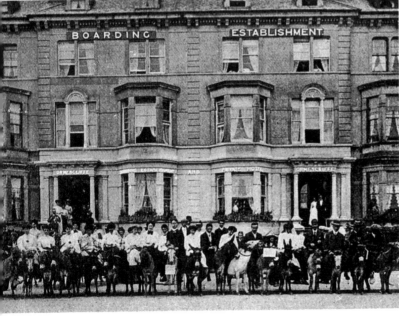

A donkey cavalcade outside the Ormscliffe, 1912 or earlier.

The National Eisteddfod at Llandudno

The origins of this unique celebration of Welsh culture are lost in the depths of time. The first recorded Eisteddfod dates back to 1176 when Lord Rhys of Cardigan invited poets and musicians from all corners of Wales to a grand gathering at his castle. Under the patronage of Welsh gentry and noblemen many eisteddfodau were held throughout Wales subsequently, though over the years they became less frequent. Iolo Morganwg (1747–1826) is credited with the revival of this festival when the first meeting of the Gorsedd was held in 1792 on Primrose Hill, London. Regrettably, though Edward Williams – Iolo's real name – was very knowledgeable about early Welsh literature he was somewhat prone to fabricating theories and histories. The Gorsedd y Beirdd (assembly of bards) was pure invention. Nevertheless, it struck a chord for a people whose language and very culture itself were under threat from outside influences and since 1818 the Gorsedd has been, and remains, a fundamental part of the Eisteddfod.

The first National Eisteddfod took place in Aberdare in 1861. Three years later it was held in Llandudno. The Gorsedd Circle of twelve large stones with a larger stone in the centre was constructed in open space near the Parade. at the end of Gloddaeth Street. The pavilion that hosted the literature and musical competitions was around the corner in upper Mostyn Street. On the opening day, 23 August, the procession assembled at the commissioner's offices on Church Walks. A musical band preceded the bards, druids, minstrels and all others involved in the ceremony. Soon they had reached the ring of standing stones and a circle was formed around them, the bards congregating within the ring of stones. A trumpet was sounded and the general opening proclamation was made. Llandudno's first Eisteddfod was underway, albeit in cold and windy conditions.

The Eisteddfod returned in 1896, the site for the Gorsedd on this occasion was slightly out of town, on the lower slopes of Happy Valley. Llandudno had grown in the previous thirty years and a large space for the circle and the many spectators could not be accommodated in the centre of town. The 10,000-seat pavilion was positioned on a relatively clear site on the other side of town, at the bottom of Vaughan Street on land now occupied by Oriel Mostyn Gallery and the former post office. The stones of the druidical circle were later incorporated into the gardens further up the valley, and new ones erected for the next visit of the Eisteddfod to Llandudno in 1963. The town had grown appreciably larger again by then, as had the Eisteddfod itself. The pavilion was erected on Bodafon Fields, where 138,000 visitors attended the ceremonies,

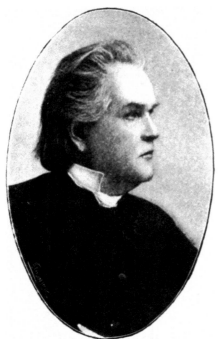

Above: The Gorsedd circle from 1963 on the lower slopes of Happy Valley.

Left: Hwfa Môn, Archdruid, 1896.

competitions and other shows and events of this Welsh cultural festival. The Queen and Prince Philip were also guests, following a tradition for the Eisteddfod to be honoured by royalty.

A Small Piece of Evidence

The scene is of North Western Gardens and beyond, down Mostyn Street, dating from around 1910. The gardens offer a peaceful, sunlit retreat for residents of the North Western Hotel from where the photograph was taken. Horse and traps patiently await customers and WHSmith & Son's Circulating Library presents books and newspapers for discerning readers. On the other side of the street a couple of chaps review the wares of Davis, fruiterer. The tranquillity of this setting is almost tangible; yet this is not the main fascination of this postcard.

From the reverse we learn that 'These postcards were sent from Wales. Aren't they beautiful?' The writer of this commendation for Llandudno hailed not from the north-west of England or the Midlands as many of the town's visitors did, but from the United States of America. The card, unused, travelled across the Atlantic, where it was subsequently written upon in March 1913 – the main topic of conversation being a lost parcel – and sent from Sheridan in Wyoming to a cousin in Omaha, Nebraska. In later years it returned, by whatever route, to north Wales.

A small piece of evidence, perhaps, but one of many picture postcards sent to distant lands, each revealing that news of Llandudno's attractions had travelled far beyond British shores by this time.

North Western Gardens and Mostyn Street, *c.* 1910, posted in Sheridan, Wyoming, 1913.

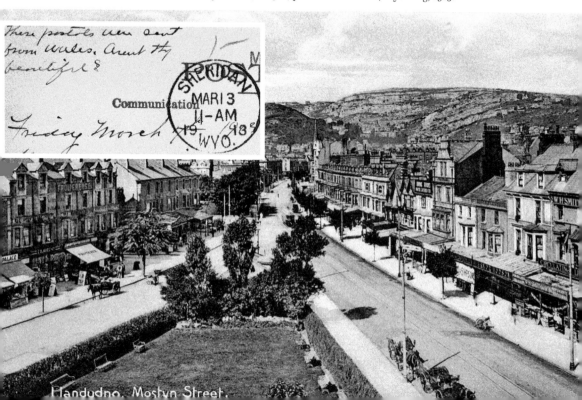

F

Flora and Fauna

Llandudno, especially the Great Orme, has been noted for the richness of its wildlife since at least 1855 when Parry listed the vicinity's scarce plants and birds in his *Llandudno Visitor's Hand-Book*. Since that time the Great and Little Ormes have been recognised as sites of scientific importance and are protected areas for nature conservation. They possess a variety of habitats that range from sea cliffs to rich heathland, limestone pavements, grassland and woodland, each bearing its own particular groups and species of plants and animals. In every season certain classes predominate. Some flowers, for example, bespeckle the land in spring, others in summer and autumn, attracting many butterflies and moths. Seabirds nest along the cliffs, other birds nest on the ground or in bushes and in winter migrant birds find the headlands a welcome place to rest during their long flights. More secretive life, lichens, mosses, colourful and unusual insects, lizards and slowworms and many others live along crevices or

The Great Orme's lawnmowers and three of the many colourful flowers found on the limestone headlands.

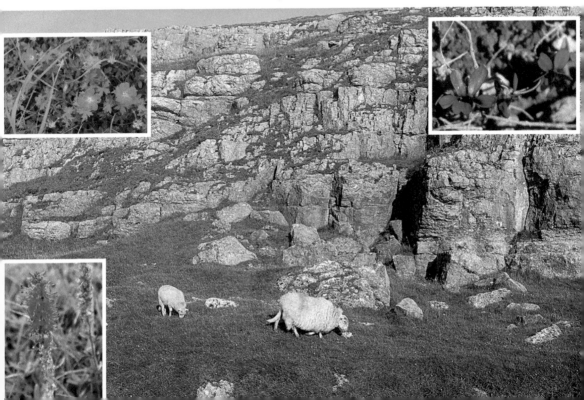

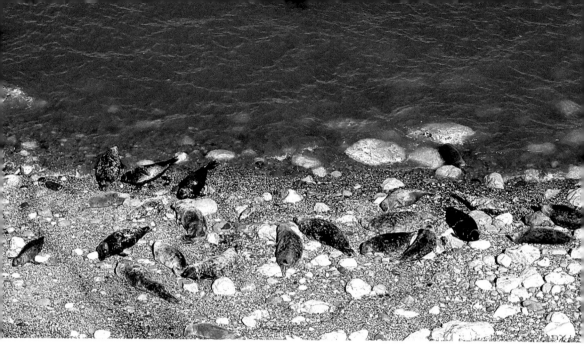

Moulting Atlantic grey seals in March, Little Orme.

hide among the grass. On the Ormes this grass is cropped flocks of sheep, which are deliberately kept so as to keep intrusive vegetation under control. In late winter and spring Atlantic grey seals come ashore to moult in Porth Dyniewaid (Angel Bay) on the Little Orme. A sign above the beach asking visitors not to disturb the seals is a reminder that all this wildlife can be disrupted and damaged, some of it quite easily.

Football in Llandudno

Thomas Edge moved to Llandudno to set up his photography business in the late 1870s. He originated from Preston and maintained a business there at the same time as he ran his concern in Llandudno. His home town witnessed the first game of football played by Preston North End in October 1878. This club developed from a longstanding cricket team that 'dabbled' in other sports outside of the cricket season. Was it then a coincidence that in October 1879 Thomas Edge's shop on Gloddaeth Street was the venue for a meeting where 'it was decided to form a football club in this town … believing that the effort will afford a welcome relief of the dull monotony of the dead season'? As elsewhere in the country, football became organised in Llandudno for cricketers with nothing better to do during the winter months, though it is likely to have been played informally for a number of years before then.

A month after the meeting in Thomas Edge's premises Llandudno was one of the founder members of the Northern Welsh Football Association. Within a couple of weeks the first-round ties for the Challenge Cup were underway. On 6 December Llandudno were at home to Bangor. The report of this match sounds more akin to one for rugby than Association football. Llandudno kicked off, with the ball going deep into Bangor territory. The Bangor backs punted it up field to their forwards who 'commenced the first of a large series of attacks on their adversaries' goal'. Bangor scored twice, but it was their third goal near the end of the match that draws strongest comparison with reports of rugby union – 'Bangor claimed hands within a few yards

of the Llandudno goal, which they converted into a goal by some good scrimmaging, carrying their opponents right through.'

Football in Llandudno was soon to become a major pursuit in town, one often associated with other activities. A team calling themselves Llandudno Gloddaeth Rovers were playing across north Wales and into Lancashire by 1884. The following year they played a home game against Blackburn Rovers, which was followed by a gala at which there was 'dancing to the strains of the Blackburn Temperance Band'. A number of teams appear to have represented Llandudno towards the end of the century and up to the First World War including Llandudno Swifts and, slightly later, Llandudno Amateurs. Llandudno Corinthians (around 1905) were a team whose players all had to be shop assistants. Llandudno North End's opponents in 1906 were Colwyn Bay (Llandudno lost, 6-0) and Gloddaeth Rovers were still playing in 1908 when they took part in the Russell Junior Challenge Cup. During this period the sport had taken on many of the characteristics that supporters would recognise today – including protests against 'unfair' refereeing decisions. The Oval in Llandudno became a venue for international matches when Wales played Ireland in 1898 (a 1-0 win for Ireland). In the same fixture in 1900 Llandudno Swifts midfielder Sam Brookes represented Wales, a game they won 2-0. Two local players who also went on to international fame for club and country competed for the youth team Llandudno Swifts in the 1970s – Joey Jones (Liverpool) and Neville Southall (Everton). The present Llandudno FC were founder members of the Welsh National League (North) in 1921, becoming champions in 1923. Since then the club has prospered and in 1988 became a limited company, moving to its present ground at Maesdu Park in 1991.

Llandudno FC.

A Fortune Made

William Hill was one of Llandudno's aerated water manufacturers (making fizzy pop, ginger beer and the like) in the late nineteenth and early twentieth centuries. He must have prospered well in this business for in 1898 he bought at auction Nos 4, 5 and 6 Hughes Yard, Back Madoc Street, paying the rather large sum of £296 for these properties. In the auctioneer's view these were much sought after and 'an extremely profitable investment' with their prospective £39 per year income. Seven years later, William had not made not a profit but a fortune.

In 1905 he met a local man who had some books for sale. The seller cannot have thought much of them (old things as they were) as he sold the job lot to William for half a crown (12.5p). William showed his new purchases to noted local antiquarian Fred Holland, who deduced immediately the true value of one volume in particular. The tale was *The Tragedie of Antonie* (printed in 1595), an extremely rare book and of some importance as it predated by a decade or more William Shakespeare's *Anthony and Cleopatra* and may have influenced his version of the story. It sold for £560 at Sotheby's in London, a sum William and Fred shared between them. In today's value the book made the equivalent of somewhere between £50,000 and £150,000 (depending on how it is calculated) – not a bad return for 12.5p. We do not know the name of the local man from whom William bought the books, nor what the chap's reaction was if he learned the true value of one of the old things.

The sale of *The Tragedie of Antonie* was an unusual affair and this postcard was issued to commemorate it.

Llandudno's Geological Foundations

The sea made Llandudno. Starting at the north-west, the core of the modern town from North to West Shores rests on rocks deposited some 541 to 419 million years ago. These mudstones formed over this vast span of time when slurries of debris flowed off the continental shelf and settled at the bottom of a deep sea. Travel a little way along the promenade to Craig-y-Don and the bedrock abruptly changes, becoming more closely dated at 478 to 449 million years – these siltstones were deposited in a shallower sea. A little inland, stretching along Mostyn Broadway, lies a band of igneous rock fashioned from the debris of explosive volcanoes at the end of this period. Further east again and the geology becomes fractured, though the mudstones formed some 444 to 433 million years ago underlying Craigside are further evidence of deep ocean deposition. In these periods there was no life on land and trilobites ruled the waves.

At the beginning of the Carboniferous period around 360 million years ago these basement rocks lay beneath a warm shallow sea close to the equator. The oceans abounded with life and fish were king of all. Plant life had established itself on land and would come to form vast forests of clubmosses, seedferns and horsetails. The first primitive amphibians had begun to venture ashore. During the early Carboniferous Llandudno drifted slowly north. At times – which lasted millions of years – it was dry land subject to erosion, while at others it was again submerged. When under the sea coral reefs formed and the skeletons of millions upon millions of minute creatures once floating and swimming at the surface accumulated on the seabed. Cockle-like shellfish (brachiopods) and other bottom-living creatures lived and died in this sediment. Over eons of time these broken remains were squashed tightly together, eventually forming limestone. Some of the larger specimens survive as fossils. Interwoven with the limestone are thin beds of shales, formed from clay deposited in the sea, an example showing that different conditions were encountered in phases of this period. The Carboniferous ended around 300 million years ago. By then Llandudno's most prominent landmarks had already formed beneath the ocean: the limestone masses of the Great and Little Ormes.

As there were several episodes of submersion and sedimentation the limestone beds were deposited as distinct sequences, with the oldest at the base and the youngest at the summit. Some strata have been modified over time, becoming dolomitic limestone. After the end of the Carboniferous vast changes took place over much of what is now Europe. Continental landmasses were colliding, causing rocks on land

and any intervening seabed to buckle and warp – as evidenced by the uplifting and tilting of strata on the Great Orme. Rocks fractured and moved apart, both vertically and horizontally. Deep beneath the seabed, fiery magma under great pressure causes any water that is present to become super-heated and mineral-rich. This rises, forcing its way into cracks and fissures of the rocks above. Minerals are then left behind as the upwelling material cools. On the Great Orme copper-bearing reserves such as malachite and azurite were the end product of this activity. An additional result of these earth movements is a fault line that runs across the north Wales shoreline, from the landward side of Bangor to Llandudno where it crosses from West Shore to North Shore, separating the two Ormes and the bedrock of Llandudno from that of Craig-y-Don. It is merely a coincidence that the ecclesiastical parish boundary closely follows the edge of this fault.

Lumps of rock are found perched on the Great Orme that somehow look out of place. In terms of geological periods. These appeared yesterday. Over the last couple of million years vast sheets of ice have periodically migrated over the land, bringing with them rocks and stones and anything else picked up along the way. When the ice melts and retreats this material is dropped and left behind. They are known as glacial erratics, being born of the ice and discarded randomly wherever they fall.

Uplifting and tilting of limestone strata, as seen from the pier.

Inset: Highly magnified azurite crystals (blue) with malachite (green) on dolomite from the Great Orme. (© Michelle Brown)

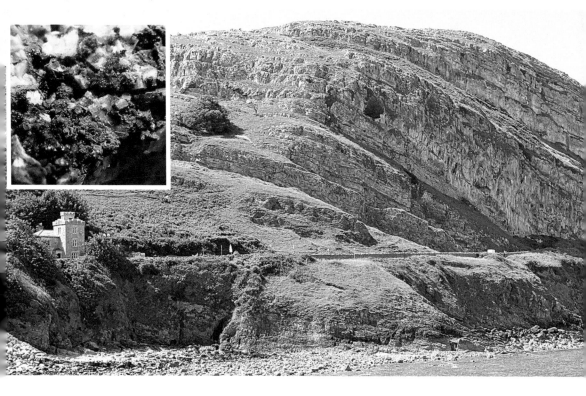

Resembling an old-fashioned loaf, these glacial erratics are found west of St Tudno's Church.

The Great Orme Tramway

The Great Orme began to enter the age of horseless carriages in 1898 with the passing of the Great Orme Tramways Act and construction, beginning in 1901, of a cable-operated street tramway with its lower station on the site of Victoria Inn on Church Walks. This opened in 1902, initially only to the halfway station. A year later the upper section was complete and everyone could now take an engaging journey to enjoy the bracing air and scenery at the summit. It was also a blessing for the recently bereaved as they and the coffin could be transported (for a fee) to the halfway station for a funeral service in St Tudno's graveyard.

This funicular system, which runs along some very steep stretches of road, is powered by cables housed in the halfway station. The trams are permanently fixed to this cable, which travels in the recess between the wheel tracks, and are stopped and started by the tram attendant (he is not the driver) with instructions passing to and from the track winchmen at the halfway station and at the summit. Until 1957, when it transferred to an electric drive, the system was powered by steam. It has been overhauled and renovated a number of times during its nearly 120 years of taking passengers up and down the roads of the Great Orme. In the last twenty years it has received grants from the Heritage Lottery Fund and the European Union among others, a sign that Britain's only cable-operated street tramway – one of only three surviving in the world – has a heritage worth supporting. It could also be said that some of its 160,000 passengers a year might not otherwise visit the grandeur of the summit were in not in operation.

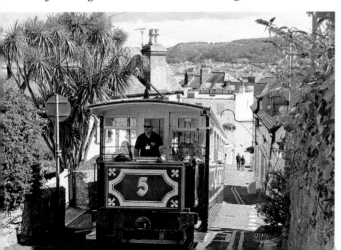

Tram 5 ascending through the older part of town.

H

The Home Front Museum

Established in 2000, the Home Front Museum on New Street offers visitors a unique and fascinating collection of memorabilia and artefacts from the six years of the Second World War, though it is not dedicated to the military aspects of this conflict. It focusses on civilians, those who kept the home fires burning. It is a living history museum where visitors can experience the sights and sounds of the home front through exhibitions and tableaux – a schoolroom, a corner shop, a chemists, the Home Guard and many more.

Before the outbreak of war the probable breakdown of international relations was already provoking anxiety. Non-combatants had been mobilised during the First World War, but technological developments since that time had advanced the

The Home Front Museum.

Inset: A schoolroom tableau from *c.* 1940.

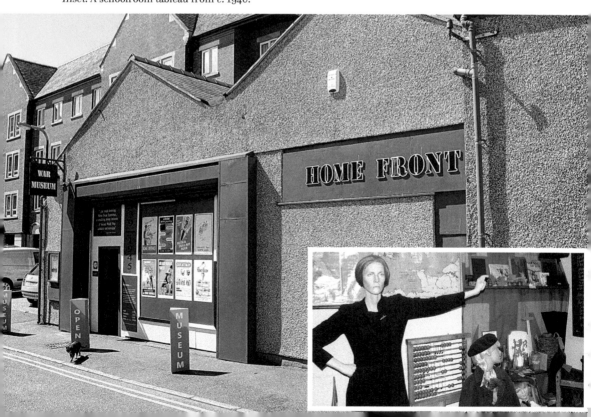

anticipation of terror from the air. Three million people were eventually evacuated out of the immediate reach of German bombers and gas masks – a precaution from gas attacks, which had devastated so many lives in the trenches of the First World War – were handed out to everyone, including ones specially designed for infants. Merchant shipping had to dodge blockades and attacks from U-boats, consequently those unable to do so never reached our shores and imported food became scarce. 'Dig for victory' became a national slogan and ration books were introduced. Millions of women worked in factories and on the land, taking on roles that before the war were generally regarded as 'men's work'. In the home luxuries were no longer available and 'making do' with more everyday items such as clothes became common. All this – and there were numerous other concerns – was life-changing for many. Visitors to the Home Front Museum, or 'The Home Front Experience' as it is sometimes tellingly called, can gain an appreciation of what life was like during this time.

William Morris Hughes

William Morris Hughes (1862–1952) became the seventh person to hold the position of Prime Minister of Australia in 1915. It was a post he would occupy for the next eight years, and included the last three years of the First World War. He became the longest serving member of Australia's parliament, amassing a little over fifty-one years of service. For much of his childhood he was raised in an altogether different place: Llandudno.

Billy Hughes, as he is better known, was son of Welsh-speaker William Hughes, a carpenter from Anglesey who was employed at the Houses of Parliament. His mother Jane was a farmer's daughter from Llansantffraid, Montgomeryshire. She died when he was a small child and Billy came to Llandudno to live with his father's sister and go to school here, spending his holidays on his grandfather's farm in Llansantffraid. He rejoined his father in London in 1874 where he became a pupil-teacher at Baroness Burdett Coutts' School, having been well-grounded in history and literature at Llandudno Grammar School. Ten years later he migrated to Australia. Here he had many odd-jobs – and periods of great poverty – and travelled in the outback.

He finally settled in 1890 in Balmain, a suburb of Sydney, and opened a small shop and mended umbrellas. He also sold political pamphlets. This period was one of ferment in the world of politics, both in Britain and Australia. The Labour movement was gathering strength and becoming organised. A room at the back of his shop became a meeting place for reformers and by 1892 he had joined the Socialist League. Billy Hughes's life in politics had begun. In 1901, he was elected for West Sydney in the House of Representatives and two years later qualified as a barrister. He was offered the post of Attorney-General but turned it down. In 1907, he was appointed to represent Australia at a shipping conference in London where his clear arguments impressed everyone, especially the chairman, fellow Welsh-speaker David Lloyd George. This was his first return to Britain.

A year after becoming prime minister he was again in Britain, attending Lloyd George's war cabinet. The young lad who had gone to school in Llandudno now sat at the highest table, on equal terms with other national leaders. He returned to Llandudno last in 1921, staying at St George's Hotel. It is recounted that he stood awhile outside his old home, Bryn Rosa.

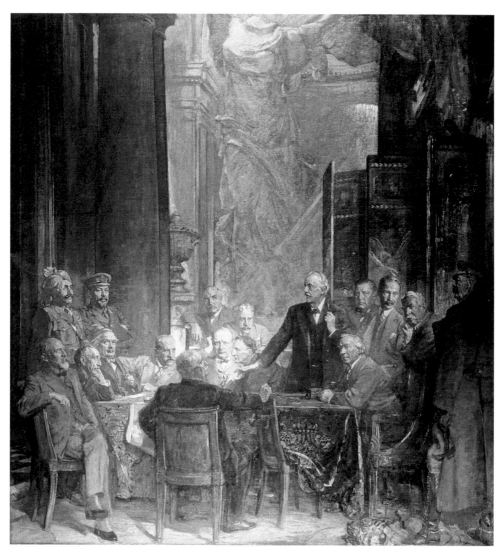

Above: In this representation of the War Cabinet, Billy
Hughes sits second left, next to Lloyd George.
(© National Portrait Gallery)

Right: Billy Hughes. (Courtesy of Library of Congress)

Infamous Seagulls

Llandudno's seagulls have featured on television, in newspapers and innumerable photographs. Even *Viz* magazine has joined in, quoting on their 'Top Tips' page a certain C. Dodgson from Oxford who expressed the view that all one had to do to recreate the excitement of Alfred Hitchcock's horror film *The Birds* was walk along Llandudno's promenade with an open tray of chips. Photographic evidence shows these beasts stealing food out of someone's hand from a perfectly executed dive over a hundred years ago and woe betide if you were wearing a hat for them to alight on to.

For some people these birds are a menace, for others they exhibit a wonderful adaptation to our ways and our transformation of the environment. Unlike many other creatures the herring gull thrives and has to be placed in the same category as the equally successful urban fox. Love or loathe them, what would the seaside be without its resident and often noisy seagulls – even if they do consider your open tray of chips or ice-cream cone an opportunity not to be missed?

Below left: They had mastered their craft at least 100 years ago, as this gentleman in Llandudno around 1920 could confirm.

Below right: Public Enemy Number One? (Courtesy of a business that wishes to remain anonymous).

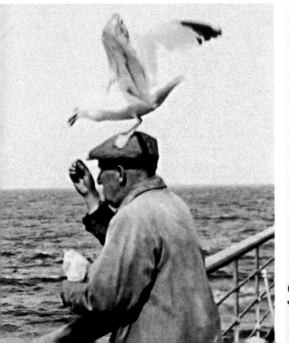

!!! WARNING !!!

SEAGULLS OPERATE IN

THIS AREA

J

John Player County League, Cricket Televised in Llandudno

The first recorded cricket match played at the Oval took place between Llandudno Visitors and Rivière's Orchestra in 1890, though the game had been played in town for many years by then. In the 1920s internationals were contested here between Wales and teams from Ireland, New Zealand and, in 1927, the West Indies. This seem destined to be the last First Class match played at the ground.

Cricket began to change in the 1960s, first with the introduction of the Gillette Cup then, in 1969, a 40-overs per side competition began: John Player's County League. Matches were played on a Sunday and shown live on BBC2. The idea was to introduce the sport to a new audience: on the week's rest day families could watch a match that didn't take an eternity to finish and where the speed of the action might be faster than a normal three-day game. In addition, some of the matches were played on grounds that had never or rarely hosted First Class players.

Llandudno was the chosen venue for a John Player's County League match between Glamorgan and Leicestershire on 22 June 1969, televised by BBC2 with Jim Laker as commentator. The weather that day was grey and cloudy with the possibility of rain ever-present. The star-studded Leicester team included Ray Illingworth who captained England from 1969 to 1973. They were first in to bat and scored 141 for 8 after 40 overs. Not a high total, but with good work from the bowlers and the luck of a couple of early wickets it might be enough to win the contest. Glamorgan, whose team included A. R. Lewis and O. S. Wheatley, started well with B. A. Davies and A. Jones hitting fast runs. They had reached 29 and 32, respectively, when the ever-present became a reality and the match was over. Glamorgan defeated Leicestershire due to their faster scoring rate.

Though this league was a success the players, especially those who were more accustomed to Test grounds, found some venues difficult to play on. There was also a lack of familiarity with the format and a number of rules were deemed somewhat peculiar – especially the one which dealt with who won a match if rain stopped play.

The Oval is home to Llandudno Cricket Club where our local team plays in the North Wales Premier Cricket League.

BBC Two's television gantry overlooking the field of play. (© Charles Eaves)

Thomas Tudno Jones

Llandudno-born Thomas Jones (1844–95) developed a taste for Welsh literature at an early age and in his teens secured several prizes for his poetry at local eisteddfodau. At the National Eisteddfod in his hometown in 1864, his *pryddest* (a long poem in free metre) gained first prize. A year later Thomas was adjudicating at Llandudno's Literary Society. His reputation in these circles was by now becoming well established throughout Wales.

One of the most important events in the eisteddfod tradition is the Chairing of the Bard (Cadeirio'r Bardd). This ceremony takes place on the Friday afternoon of the National Eisteddfod and the winner is refered to as 'Y Prifardd' (The Chief Bard). Tudno gained this honour in the years 1875 (Pwllheli), 1877 (Caernarfon), 1888 (Wrecsam), and was probably most remembered of all in 1890 at Bangor for his poem 'Y Llafurwr' (The Labourer) where he was presented with the Chair by Elisabeth, Queen of Romania.

Thomas Jones is the name by which he appears in sources up to the early 1860s. As he began to compete in eisteddfodau he took the druidical name 'Tudno'. By the time of the 1871 census Thomas had adopted Tudno as his middle name. Outside of his literary achievements he was editor of the *Llandudno Directory* from the late 1860s up to 1874, the year he took on the role of editor for *Llais y Wlad* (*The Voice of the Country*), a newspaper published in Bangor. This he relinquished in 1880 to undertake

a course of education preparatory to Holy Orders. He subsequently attended St Bees Theological College, Cumbria, and was ordained by the Bishop of Bangor in 1883. His first curacy was spent at St David's Welsh Church, Liverpool. After a period in charge of Llanyblodwell parish, near Oswestry, he returned closer to home when he was licensed to the curacy of Llanrwst, a post he resigned in 1893 due to ill health. On his departure parishioners presented him with a purse containing 100 guineas (£105), which says rather a lot about his character and how well he was regarded by them. In 1906, the splendid stained-glass King David window was placed in the north-east wall of St Tudno's Church in memory of Llandudno's celebrated bard.

Above: Revd Thomas Tudno Jones.

Right: Detail from the King David window in St Tudno's Church, dedicated to Thomas Tudno Jones in 1906. (Courtesy of St Tudno's Church)

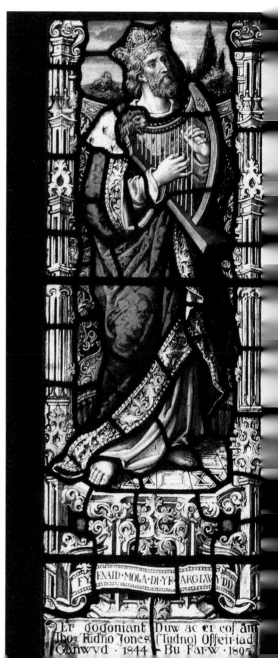

Kashmiri Goats

From the centre of town a small white-coated flock of sheep-like animals can often be noted leisurely rambling about on the higher grassy slopes of the Great Orme. These creatures are a long way from their place of origin. They are Kashmiri goats whose ancestral home is northern India. This feral herd numbers around sixty animals and have lived happily on the headland for over 130 years. They arrived here via a somewhat roundabout route. In the early 1800s, Christopher Tower, a squire from Brentwood in Essex, stumbled upon a large herd that had been taken from India to France. He purchased two of these animals, hoping to form his own herd from which he could manufacture cashmere shawls. The goats not only tolerated British weather conditions but thrived and a shawl was eventually produced, which he presented to George IV in the 1820s. The king liked the gift so much he also accepted two of Squire Tower's animals. As in Brentford, so at Windsor and a sizable herd was soon

Mother and kid near the Rocking Stone.

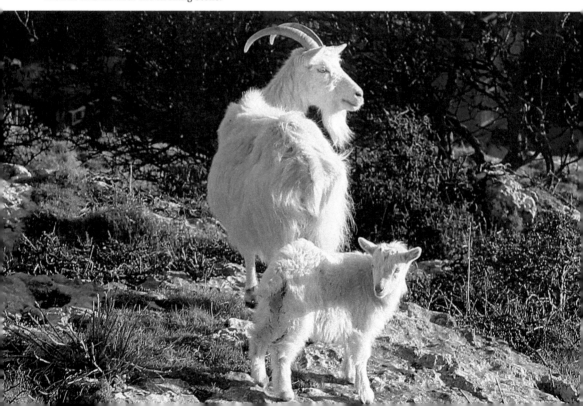

roaming the park. Towards the end of the century Major-General Sir Savage Mostyn acquired a pair, though they did not fare well and were eventually released onto the Great Orme.

The goats will not run away when approached as sheep do, but will placidly saunter away a short distance. They are agile creatures and can walk along what appear to be the most precarious of ledges in their search for food. Contrary to popular belief they do not eat anything and everything, but search out a particular food source when it is in season, including bracken, bramble, gorse, hawthorn, stinging nettles and in autumn, grass. The kids are born in March, sometimes in February, and can occasionally be found alone, as if abandoned. They have not been; the mother is off eating and will return to suckle her young. If they are picked up there is every possibility the mother will reject them when they are restored to her smelling of humans. These goats help maintain the balance of nature on the Great Orme and are companionable creatures – albeit at a respectable distance from us.

Thomas Kendrick

The life of Thomas Kendrick mirrors Llandudno's development during the nineteenth century. He was born Thomas Cynric in 1821 in a cottage close to Pant-y-Wennol Cave behind Bodafon Fields. At this time the copper mines on the Great Orme were developing apace and only a few peasant cottages stood on the low-lying land between the Ormes. His father died in 1835 and his mother was removed from the area under Poor Law regulations with her four young children to their parish of settlement, her husband's birthplace, Ysceifiog in Flintshire. They had returned by 1841 to an address listed in that year's census as Pen yr Ogof, with their Welsh surname anglicised to Kendrick. He and his brother William were employed as agricultural labourers. Ten years later, on the next census, the two of them are recorded as copper miners and living with their mother and two visitors, one of whom was Hugh Hughes, a stonemason from Aber. Thomas lived alone in 1861 (he never married) and had reverted to his original occupation of agricultural labourer – by then the mines were no longer a major local employer. It is probable that the two occupations enumerated from 1841 to 1861 were interchangeable, carried out when work was available.

Sometime before 1871 Thomas had taken up the occupation of lapidary, shaping and polishing pebbles collected from the beach and then selling the finished products to an increasing number of tourists visiting the growing resort town – a livelihood he could never have dreamed of in his early years. Did Hugh Hughes unwittingly influence Thomas's later choice of career? His address had also settled down to being recorded as Tan yr Ogof ('Below the Cave'). This row of six cottages was owned by a Mrs D. Lloyd in 1876, charging a rent of £4 per year for each, one of the lowest in town. In the census of 1891 – the first to survey language spoken – he is enumerated as speaking Welsh only, which perhaps is surprising given his business and the contacts he had with English-speaking tourists. Thomas died in 1897 at the age of seventy-six, leaving a fortune amounting to £436, which he left to his sister, Anne.

A possible basis for this wealth is to be found in two caves (now on private land) located up the slope behind his cottage. In the lower cave, used as his lapidary

workshop, he made a remarkable discovery in the winter of 1879. He was clearing out the cave and enlarging it, breaking through material accumulated over thousands of years and digging up the floor when he uncovered bones of various creatures and ancient artefacts. This find immediately attracted the attention of the scientific community. Further examinations of the site were undertaken from early 1880 and added to this material. The bones of badger, bear, boar, goat, horse and others were revealed along with four human skeletons. The artefacts included animal teeth perforated for suspension (a necklace?), flint fragments, a polished stone knife and, most remarkably, a decorated and incised horse's jaw bone. They date from the end of the last ice age – around 12,000 or so years ago, in the Palaeolithic Period (Old Stone Age) – and suggest that this cave was used for ritualistic and burial purposes rather than as accommodation. They also made Thomas Kendrick's cave a must-see destination for tourists in town, for which he charged an entrance fee and, no doubt, promoted his lapidary business. Much of this important archaeological collection is now exhibited in Llandudno Museum.

Thomas Kendrick.

The Lifeboat

Llandudno's first pier was severely damaged by a devastating storm in October 1859. This tempest destroyed many ships around the coast, one of which was the *Royal Charter*, wrecked off the coast of Anglesey with the loss of over 450 lives. Before the year was out two local men had requested that the Royal National Lifeboat Institution (RNLI) station a lifeboat in Llandudno. This – the *Sister's Memorial* – arrived in January 1861 and was housed in what is now Augusta Street, opposite the railway station. A second *Sister's Memorial* came on station after the first capsized while attempting to assist a ship in distress 8 miles off the Great Orme's head in 1867. Given the dangerous and rough conditions in which these lifeboats operated it was almost unavoidable that they too might succumb to misfortune. The second *Sister's Memorial* herself capsized in 1887 and *Sunlight No 1* was sent to Llandudno. These lifeboats were hauled by horses from the station to the promenade and were then launched from North Shore. Due to issues of cost and limited availability of these animals they were withdrawn in 1899 and launching the boats was carried out using manpower alone. *Theodore Price* arrived in 1902, and in 1903 became the first vessel to be housed in the new lifeboat station on Lloyd Street. From this position the boat could be taken to either North or West Shore for launching.

Theodore Price remained on station until 1930 and was then replaced by reserve lifeboats. When *Thomas and Annie Wade Richards* arrived in 1933 it was Llandudno's first motor-driven lifeboat – before then boats were powered by sail and, to a greater extent, by manning the oars. With this new boat came a motorised launching tractor. Over the ensuing years vessels were superseded by larger and faster boats and in 1965 Llandudno became the first station on the north Wales coast to house an additional inshore lifeboat. The facilities on Lloyd Street were beginning to prove inadequate for purpose. After much local debate the decision was made to build a new station below Bodafon Fields on North Shore. This was completed in 2017, designed to house a new 25-knot Shannon-class all-weather lifeboat and a D-class inshore lifeboat, together with their launching equipment. With this the sole surviving practice in the British Isles of all-weather lifeboats being drawn through a town centre to be launched came to an end. The much appreciated lifeboat *Andy Pearce* was withdrawn from service and replaced in the new station by *William F Yates*, which has a revolutionary new launching and recovery system. The station, with its enhanced facilities for both boats and crew, also houses a shop and visitor centre. From its new position Llandudno's lifeboat – which relies on voluntary contributions by the public – continues the fine tradition of saving lives at sea.

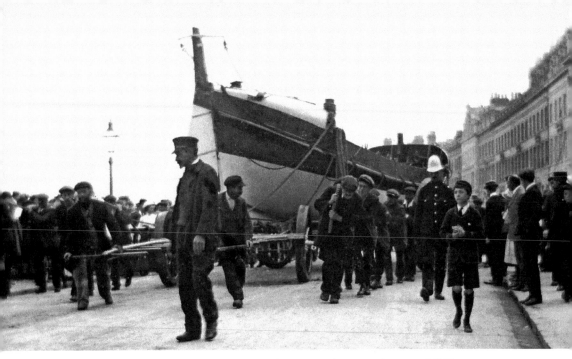

Above: Lifeboat *Theodore Price* being hauled along the promenade in 1910. (Courtesy RNLI)

Below: The new station on North Shore, which opened in 2017.

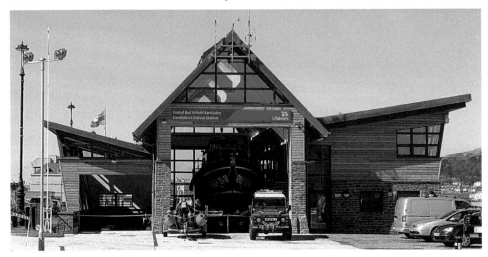

The Lighthouse

Many ships that have been lost to the sea lie across the north Wales coastline and on to Liverpool. Since Llandudno Bay's first recorded disaster in 1641 many more have foundered and around the Ormes. The Great Orme was a particular hazard, projecting its sheer cliffs seawards into shipping lanes. Conwy Bay here and on towards Anglesey and the Menai Straits account for countless other wrecks.

The first lights on land to guide shipping were likely to have been fires burning on the tops of headlands and close to harbour entrances. As seafarers have known since ancient times, if these are placed on a platform they can be observed from further

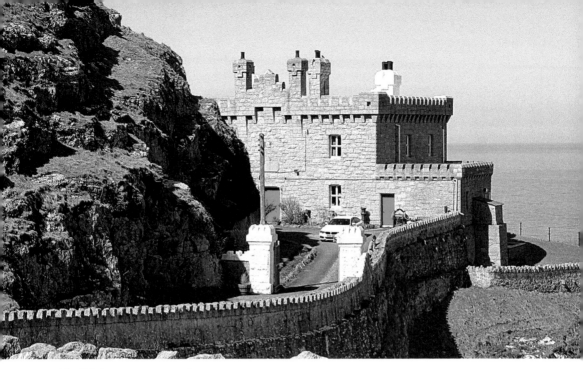

The lighthouse, now a guest house.

out to sea. By the eighteenth century transatlantic and worldwide sea traffic was expanding rapidly and lighthouses began to be installed around Britain. Liverpool rose to become a major port and the bulk of her shipping passed along the north Wales coast. By the early 1860s the decision had been made to help guide seaborne traffic sailing in this direction. The lighthouse situated at the most northerly point of the headland was completed in 1862 and stands 99 metres above sea level. This fortress-like building was designed to be managed by a lighthouse keeper and an assistant (or two). Internally, two households were separated by a tall wooden hallway, which remains in place today. It shone its light across the sea one last time in 1985 and is now a guest house with wide views along the coast and the ocean.

The Little Orme

The sweep of Llandudno Bay curves between the two headlands of the Great and Little Ormes. Though these share many features in common, such as being composed of limestone deposited in the same period, there are contrasts between the two, and not simply that of size. The Great Orme and the sea currents around it made the tombolo upon which Llandudno stands; it wholly belongs to the town whereas the Little Orme is shared with Penrhyn Bay. The Little Orme's geology differs from its neighbour in that it largely composed of a series of large reefs formed along the edge of a carbonate platform rather than as horizontal strata. A consequence of this is that quarrying in the late nineteenth century was carried out in quite a different manner to that on the Great Orme. A 3-foot narrow-gauge industrial railway, which operated at three levels within the quarry, transported the excavated blocks of stone to a pier on the Penrhyn Bay side of the headland. Over the years of its operation – 1889 to 1936 – nine engines were on site. It is said that the main quarry was located on this side of the Little Orme on Lord Mostyn's instructions so as not to blight the view from North Shore.

Though much evidence from earlier times is likely to have been destroyed by quarrying, significant archaeological finds from the Neolithic onwards have been found on the Little Orme. These include the remains of 'Blodwen', discovered in a fissure in the rocks during quarrying work in 1891. Blodwen lived in these parts around 3,500 BC, a time when agriculture was being adopted as a new way of life. In Rhiwledyn Cave on the north face of the headland a number of skeletons and associated artefacts were found dating to the end of the Neolithic. Bronze Age discoveries include an axe from around 1450 BC, composed of copper extracted from the Great Orme mines. Isolated Iron Age and Roman finds include a hoard brought to light in 1981 dating to around AD 300 comprising sixty-eight coins, five ox-head bucket mounts, two brooches and other items. A number of similar hoards from this time have been unearthed in the wider vicinity begging the question as to what circumstances were causing disquiet sufficient to make individuals secrete away their treasures. Many of these ancient artefacts are on display in Llandudno Museum.

On the Penrhyn Bay side of the Little Orme a left turn off the roundabout leads to Penrhyn Old Hall, a venerable building whose origins go back to at least the 1530s. A ruined chapel a little to the east of the hall dates to around the same period and was a local stronghold of Roman Catholicism in an age when practising this religion was a dangerous affair. In 1586, in a cave hideout towards the top of the headland, two Catholics, Robert Pugh of Penrhyn and William Davies, a priest recently ordained in France, printed on a wooden hand press *Y Drych Cristianogawl* (The Christian Mirror). This small volume of 180 pages was the first book printed in Wales. It led to both men becoming outlaws after Sir Thomas Mostyn was directed to arrest them. Pugh eventually evaded capture; Davies was executed in Beaumaris in 1593. Conflict of a different order came to the Little Orme in 1940 when the Royal Artillery School, recently transferred to the Great Orme, set up a practice battery within the old quarry.

One other feature the two Ormes share is the wealth of wildlife they possess. Rhiwledyn Nature Reserve, on the south-western flank of the headland, is a 12-acre site administered by the North Wales Wildlife Trust.

The Little Orme from the Great Orme.

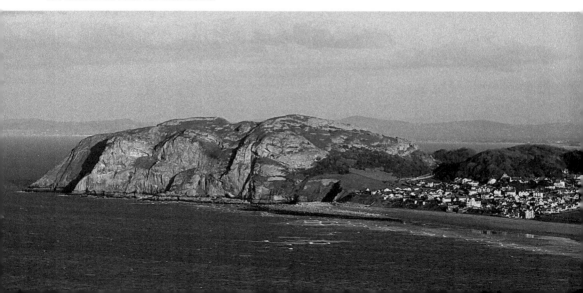

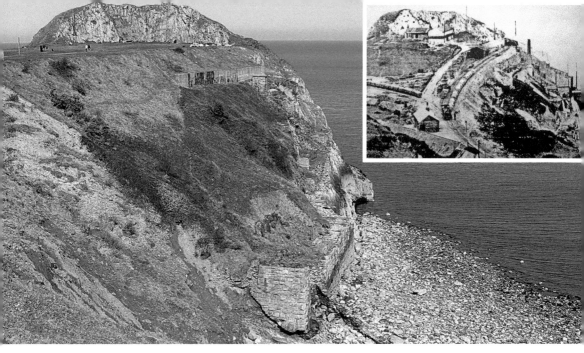

Relics of quarrying operations and as they were in the late nineteenth century. (Courtesy Llandudno Museum)

Llandudno?

Llandudno is a truly wonderful place, yet it has no shops, commercial activities or streetlights. It does have some of the most prestigious residential properties and beautiful bays and beaches in the country, but it is not in Wales. Confused?

This Llandudno is a residential suburb of Cape Town, South Africa. The main beach lies between two headlands that slightly resemble the Great and Little Ormes. The similarity was seemingly close enough for this growing suburb to be named after our Llandudno in 1903 when the valley that terminates at Kleinkommetjie Bay was declared a township.

It's Llandudno, Jim, but not as we know it.

Lletty'r Filiast.

Lletty'r Filiast

The Neolithic, New Stone Age, was a time of fundamental change. Hunter-gatherers, often depicted as 'cavemen', were learning new ways of adapting to the environment – they perhaps had to, as the climate was becoming warmer around 11,500 years ago after the end of the last ice age. Seasonal wanderings following herds and visiting woodland areas rich in edible plant life was gradually transformed into a more settled, agriculture-based way of life. In the Middle East this had been fully realised around 11,000 years ago and small towns were beginning to appear.

There is strong evidence to suggest that the western seaboard of Europe was well travelled by Neolithic peoples, for trade and seeking new places to settle, and, no doubt, for more nefarious activities. The links with Ireland may have been particularly strong for north Wales – the earliest evidence for farming in the British Isles comes not from southern England but from Ireland. The first indications of farming in Wales date to around 3500 BC. Religious and burial practices also underwent drastic modifications and people now established in a small area began to adorn their landscape with tombs and sacred structures – the most famous British example is probably Stonehenge. Lletty'r Filiast and its accompanying tumulus was erected sometime around 3000 BC. This small portal dolmen has been damaged, probably centuries ago, but remains evocative of an ancient people. At the time of building it stood within a closed valley where the water disappeared into a sinkhole. This valley with its exposed green malachite veins against the greys and browns of the limestone was perhaps a scene of wonderment for Neolithic folk, adding to its sacred aura.

Llewelyn Avenue (formerly Llewelyn Street)

The first Tabernacle Welsh Baptist Chapel on the site where upper Mostyn Street meets Llewelyn Avenue was built in 1813. It was rebuilt in 1835 and is the building at the far right in this image from 1856. The entire street then comprised the chapel and six newly constructed houses to its right. Much older buildings from the time of the original village are indistinctly visible in the background, halfway up the slope of the Great Orme. The photograph was taken from what is now the town end of Gloddaeth Street – marked out by the boundary wall in the foreground but not yet built.

A snapshot of the newly erected houses of Llewelyn Avenue can be gleaned from the *Original Llandudno Directory & List of Visitors*. The issue for 24 July 1858 records,

after listing the chapel, the post office run by William Powell, postmaster, grocer and stationer with his wife and six children. Also resident that week were at least fourteen visitors from the Worcester area. This dual-purpose arrangement appears to have been the situation for most houses on Llewelyn Avenue – and we might assume for the majority of newly built properties in Llandudno at this time – a resident family headed by a tradesperson/retailer accommodating several summer visitors, many deriving from the English Midlands.

From these early days Llandudno grew and developed around new streets that once, for a short time, faced open countryside. The chapel has been rebuilt and amended, firstly by Richard Owens in 1875, then in 1902 by G. A. Humphreys when the Ionic colonnade to the right was added.

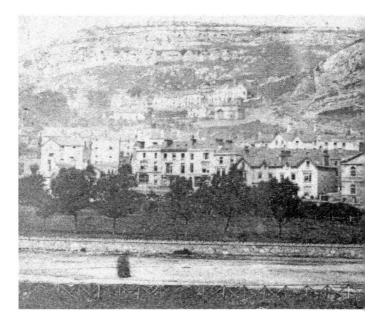

Right: A new street in a new town: Llewelyn Avenue, 1856.

Below: Llewelyn Avenue.

Marine Drive

The focus for Llandudno's early visitors centred on North Shore, its beach and the sea. The summit of the Great Orme was an agreeable destination for the more active, as it had been since the late eighteenth century. It was soon realised that a path around the Great Orme would be an additional attraction, taking advantage of the natural splendours on offer. The surveying and construction of this path became the responsibility of Reginald Cust, a trustee of Mostyn Estates. It opened in 1858. However, while it provided for a route around the headland, the narrowness of stretches of it and the sheer drop down to the jagged rocks and swirling sea below probably added a little too much excitement for some of its users. A further flaw was that its 5-mile length could only be travelled upon by pedestrians. Suggestions were quickly forthcoming to rebuild this path, making it safer and, importantly, to be of such a standard that carriages could run along it. It was to become a drive rather than a walk.

Unfortunately the machinery of change can sometimes turn rather ponderously. By 1865 tenders were being sought to build the new drive, but nothing came of this. It took a further ten years before the grand ceremony of cutting of the first sod could be held. Two years later, in June 1877, the workmen were gathered in the refreshment

Marine Drive.

rooms of the Royal Hotel for a grand dinner in gratitude for the speed and quality of their work. In the report of this event may lie clues as to why it took so many years for the drive to be built. There had been 'a good deal of opposition' to it which fell into two categories. The first was 'that the natural beauties of the scenery round the Head would be to a great extent effaced'. Secondly, some 'predicted that the engineering difficulties would be so great as to render the scheme a most expensive one'. By the following year when the date plaque of '1878' was attached to the new North Shore tollgate there were still the odd complaint heard, but soon reports were appearing that told of the success of Marine Drive. It remains a popular accomplishment of Victorian civil engineering.

Dame Nellie Melba and Other Famous Artistes

The *Llandudno Advertiser* of 21 May 1910 proudly announced: 'We learn that Madame Melba will pay a visit to Llandudno on Saturday, August 6th, and give a matinee at the Pier Pavilion.' The next day the Pier Company was inundated with enquiries for seats as this was an artiste of international renown. On the afternoon of the show the Pavilion held an entranced audience of 3,000. So many wished to see and interview this famous prima donna after the performance that she had to return to her room in the Grand Hotel 'through a private underground passage', though before departing she revealed: 'this is my first visit to lovely North Wales, and what a beautiful country it is.' Dame Nellie Melba returned to Llandudno for a sell-out performance in the Arcadia Theatre on 23 July 1923. On this occasion the famous singer signed her autograph for a grateful fan.

The Pier Pavilion and Grand Hotel, 1910.

Inset: Dame Nellie Melba, 1923. (© Charles Eaves)

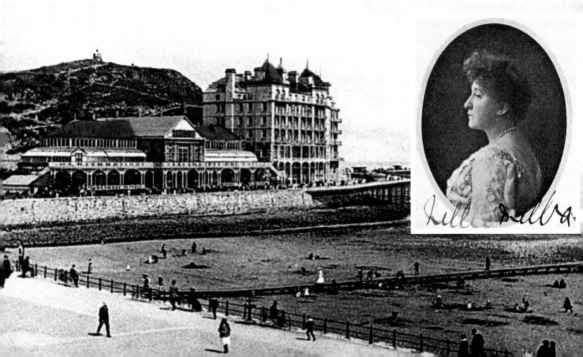

Other famous performers to appear in Llandudno over the years include Layton & Johnstone, a very successful vaudeville duet from the USA. They resided in Britain from 1924 to 1935 and toured extensively, including at the Palladium in Llandudno on 8 August 1929. During this period they sold over 10 million records – perhaps their most well-known song is the catchy 'Bye-Bye Blackbird'. Llandudno has attracted top-line acts in the decades since then, including singers such Cliff Richard and in 1963 the Beatles. More recently Billy Ocean, Robert Plant, James Blunt, Elaine Paige and the Happy Mondays have graced the town with their shows. In 2018 Gary Barlow is set to make an appearance at Venue Cymru.

Mostyn Street

Llandudno's Enclosure Bill was passed in 1843, making Lord Mostyn the freeholder of 832 acres of common land on which Llandudno would be built. The first leases for 176 lots were put up for auction in 1849 and Messrs Williams and Jones, surveyors and architects of Liverpool, received instructions from Lord Mostyn to prepare working plans and estimates for the formation of the principal streets, which, along with Church Walks and Mostyn Street, were 'Llewelyn Street, Madoc Street, Clonmel Place, Lloyd Place, Vaughan Place and Cynric Place'. By January 1850 extensive drainage was being undertaken on the low-lying land beneath the Great Orme and it was excitedly reported that 'the place' was taking on an 'animated appearance, especially among the builders' – being erected were the grand total of a boarding house and three dwellings on Church Walks and three houses on Mostyn Street. The creation of the seaside resort had begun.

Mostyn Street was planned as the main thoroughfare through the new town. Its line follows the curve of the bay, running parallel with the promenade. Other roads intersect Mostyn Street at right angles, forming a coherent grid pattern of building.

The promenade on the left, with Mostyn Street to the right running parallel with it.

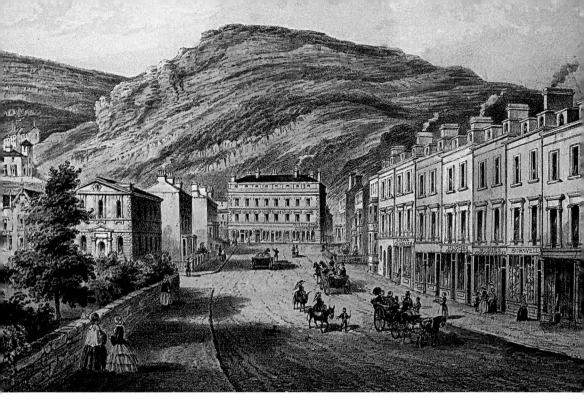

Artist's impression of the upper end of Mostyn Street, *c.* 1860. The building facing is now the Empire Hotel. The street on the left is Llewelyn Avenue.

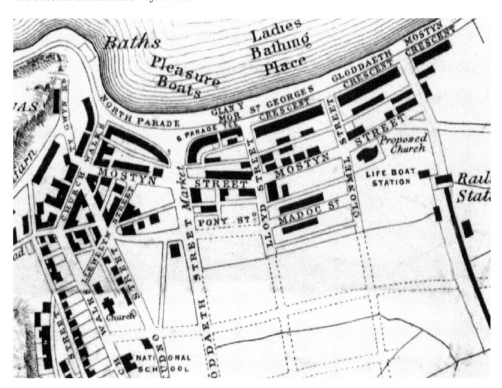

Parry's map shows the extent of the built-upon plots in the early 1860s.

The early development of the town was centred on the promenade crescents and around Church Walks, as shown by Parry's map from the early 1860s. The upper part of Mostyn Street adjoining Church Walks was largely complete then, though much building space remained vacant along the rest of the road. Some areas, such as the western side of Llewelyn Avenue, were built as one unit, while other parts of town grew in a more piecemeal fashion as plots were sold and developed. Building work mainly took place from autumn to spring – outside the main tourist season, so as not to inconvenience the town's visitors. Within thirty years the blocks either side of Mostyn Street would be complete and the road itself would eventually extend eastward, as Mostyn Broadway after Vaughan Street and then Mostyn Avenue in Craig-y-Don, until terminating at Bodafon Fields. Mostyn Street emerged as the town's foremost retail area and today many businesses of varying types, shopping arcades, banks, cafés and restaurants, the library, churches and other amenities of a town centre can be found along it.

Llandudno Museum

The original site of Llandudno Museum was Rapallo House in Craig-y-Don, the former residence of J. C. Chardon, who left his extensive collection and home to the town in 1925. Seventy years later the museum relocated to larger premises on Gloddaeth Street and Chardon's somewhat eclectic gatherings from around the world merged with a diverse and rich array of material and artwork from Llandudno and its hinterland. Palaeolithic finds dating to around 12,000 years or so ago from Kendrick's Cave are displayed, as are the remains of 'Blodwen', a local resident in the Neolithic, and Roman artefacts from the fort at nearby Caerhun on the banks of the River Conwy. The collection continues through time, spanning the years up to the twentieth century and the two world wars. This museum, while housing numerous fascinating items, also provides educational experiences for children and schools as it continues to grow and evolve.

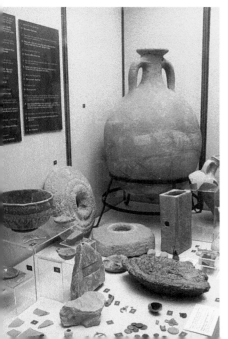

A display of Roman artefacts found in the area. (Courtesy of Llandudno Museum)

N

The National Westminster Bank

By the beginning of the twentieth century the resort of Llandudno had witnessed nearly fifty years of growth and development and was now fully established. Some of the incomers who travelled to the rising town to set up trades and businesses and make it their home had prospered, as had many local people. In 1902 the new Town Hall had opened its doors and next to it, along Lloyd Street, the Ebeneser Wesleyan Chapel (now the Emmanuel Christian Centre) was completed in 1908–09. Such grandiose buildings tell of financial success. On the other side of the Town Hall, and dwarfing it, on the junction with Mostyn Street, is a further show of early twentieth-century wealth, the National Westminster Bank. This imposing building was designed by E. C. R. Palmer, architect for the National Provincial Bank. It opened in 1920. Pevsner's *Architectural Guide* calls it a 'lofty Portland stone pile … a bravura display worthy of the City of London'.

The National Westminster Bank.

A Distant Obelisk and Protecting Wildlife

From many vantage points in Llandudno a feature resembling Cleopatra's Needle can be observed standing proudly on the summit of a hill some 3 miles or so to the south-east, overlooking the village of Esgyryn. We might wonder if it celebrates a famous military victory in ancient days or, perchance, was set in place by a mourning and tearful nobleman to mark the tomb of his beautiful beloved lady. No, afraid not, it is a folly built by a local hotel in the early 1990s. Much controversy surrounded its construction, so perhaps it commemorates this battle.

The obelisk (map reference SH 8050 7891) lies on a Site of Special Scientific Interest and in spring and early summer orchids, primroses and other wildflowers grow through the surrounding grassland, which is then swathed with pinks and reds and yellows. From the summit splendid views unfold across fields and hedgerows towards Llandudno and Colwyn Bay and, in the other direction, the town of Conwy and the Conwy valley with Snowdonia beyond. In the distance to the north the sparkling sea sweeps along the horizon towards Anglesey.

Nearby are two nature reserves. To the north-east is Bryn Pydew (SH 818 798), underlain by limestone of the same period as the Ormes, which has many habitats favoured by lime-loving plants and associated creatures, including a woodland in

The obelisk amid spring flowers.

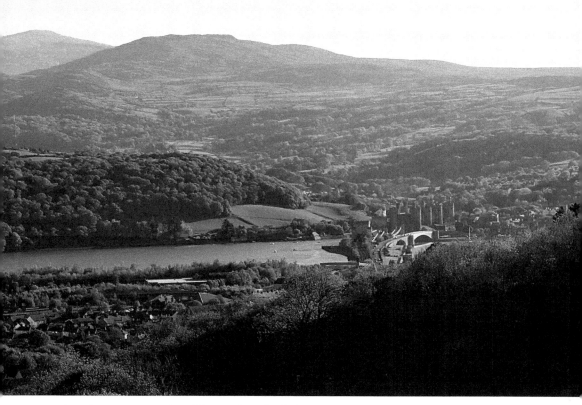

Snowdonia, Conwy Castle and the river from the clifftop above a small abandoned quarry next to the obelisk.

which the ash and the yew flourish and where early purple orchids flower in spring. To the north-west lies Marl Hall Woodland Trust Reserve (SH 799 788). This ancient woodland is home to a variety of native species, such as oak and pine. In spring its floor is awash with bluebells, snowdrops, ransom and pyramidal orchids. Up above reside the jay, the greater spotted woodpecker and many other birds, airspace shared with the scarce, iridescent, green cistus forester moth.

The obelisk may be a folly, but it stands as a wonderful landmark for those wishing to discover fascinating countryside and impressive scenery.

Oriel Mostyn Gallery

For those unversed in the Welsh language, the word '*oriel*' might be presumed to be the name of a person or place. It is Welsh for 'gallery' – the Welsh language works to a different word order (as do many other languages) than English. Oriel Mostyn is the Welsh equivalent of Mostyn Gallery – this arrangement of words from both languages on bilingual signs is quite common. Its original name was Mostyn Art Gallery, as portrayed in the ornate arch above the entrance door.

Under the patronage of the very influential Lady Augusta Mostyn, a cultural centre was envisaged for Llandudno's residents, especially those who were considered to have less access to education and the arts, the 'lower classes'. It opened on the site of the 1896 Eisteddfod pavilion in 1901, designed by Mostyn Estates' chief agent, architect and surveyor Dr George Alfred Humphreys. Along with the Imperial Buildings (1898) and the Post Office (1904) it is one of three of his designs on this stretch of Vaughan

Ornate metalwork above the entrance to Oriel Mostyn Gallery.

Street that bear similar orange terracotta façades in a 'Northern Renaissance' style. The educational aspects of the gallery never quite reached their full potential and although the arts had some success the decision was made around 1912 to close the centre.

Over the next decades it had an assortment of uses: a drill hall during the First World War, commercial premises, and simply as storage rooms for which it was used by the relocated Inland Revenue during the Second World War. After the war the building housed Wagstaff's Piano and Music Gallery, a role it retained until 1976 when proposals were made to return this space to its primary function. It opened as Oriel Mostyn Gallery in 1979 and gained national and international recognition for the high standards maintained in exhibiting a broad scope of the best of contemporary art. Following a design by architect Dominic Williams the interior was remodelled in 2010 and a wide range of art forms can be experienced in five galleries. Oriel Mostyn Gallery charges no admission fee, making this freely available for everyone, which, perhaps, resonates with Lady Mostyn's original intention.

Osborne House

Osborne House was one of the earliest to be built on the low-lying plain beneath the Great Orme when Llandudno's Enclosure Bill was implemented after 1849. A painting currently in Llandudno Museum by R. Green shows the building in 1852 with the roof still to be completed, comprising two storeys with three small-pane windows on each floor. It is shown as one of four dwellings along this stretch of road. Soon it would be joined by others as development of the new resort took hold. Within twenty years or so it had been extended to three storeys with an attic storey; also added was a facing of dressed stone.

A partial history of this building at No. 17 North Parade can be observed through the decennial census. No one was at home – or it was unoccupied – when the first census to include it in 1861 was taken. Ten years later it had become a lodging house run by Elizabeth Williams who had a servant named Jane Thomas, both born in Bangor. By the time the next census came around in 1881 its use had changed to a private dwelling housing two separate families. The first was headed by Joseph Burton, a chemist's assistant born in Nottinghamshire with his wife Eliza from Devon, along with their two children, Joseph's sister and three servants. Joseph and his family had lived at No. 22 Madoc Street in 1871, and by 1891 he was a chemist on his own account at No. 98 Mostyn Street. The second family residing in Osborne House was Charles

Hunter, a merchant born in Manchester, with his wife Emma, born in Bombay, India, and their six young children, along with two servants. Of the Hunters there appear to be no further records in Llandudno. Osborne House remained a private dwelling in 1891, the census night when it was occupied only by two servants. However, eight years previously in 1883 it had been bought by John Walker from Liverpool, though born in Ayrshire, Scotland. We might note that none of Osborne House's heads of households, as far as can be discerned, were Llandudno-born. The town was being populated as it grew largely by those born further afield, occasionally much further afield, as was the case for Emma Hunter.

John Walker was a wine and spirit merchant. His brother, Peter – of Coed-y-Glyn near Wrexham and of Liverpool, a brewer – died in 1882 leaving the sum of £227,000 in his will, the most part to be shared among his family. Could John have bought Osborne House the following year with any share of the inheritance he might have received? He and wife Margaret were very active in Llandudno's affairs and donated often to local causes. In 1899, the south aisle of the newly built St Paul's Church in Craig-y-Don was added at his expense. Five years later he presented the library 'with a beautiful volume of Tennyson's works'. The next year Margaret and one of their daughter's raised £55 from their fruit and flower stall in the Town Hall, as part of the church bazaar. Sadly, tragedy struck this family in February 1916 when son John Arthur Walker, a captain with the 10th Royal Welsh Fusiliers, was killed in action, aged twenty-four.

Since 2001 Osborne House has been a luxury hotel with six suites, a sumptuous restaurant, bar and spacious lounge.

Osborne House, No. 17 North Parade.

Parish Boundaries, Two Diocese and the Poor Law

Churchgoers may have noticed that St Paul's in Craig-y-Don resides in the Diocese of St Asaph. If the following week they worship a little way down the road at Holy Trinity Church they may recognise the service taking place in the Diocese of Bangor. As a general

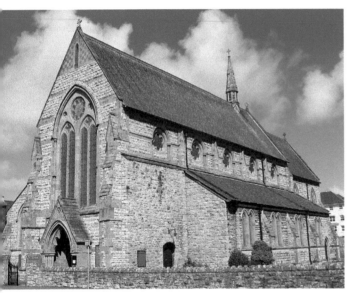

St Paul's Church, diocese of St Asaph.

Holy Trinity Church, diocese of Bangor.

rule a settlement the size of Llandudno might be assumed to lie in one parish, certainly in one diocese, but this is not the case. An ancient dividing line runs through the town.

The line of the ecclesiastical parish boundary runs approximately from the promenade, along Vaughan Street to the railway station, down the tracks and then to West Shore. To the north and west is the parish of Llandudno and the Diocese of Bangor, separated by this boundary from Eglwys Rhos parish (formerly Rhos-Cystennin) and the Diocese of St Asaph. An earlier demarcation ran roughly along this route and remarkably can still be traced on the ground. Boundary stones carved with 'LL P' on one side (Llandudno parish) and 'ER P' on the other (Eglwys Rhos) can be followed from the promenade opposite Mostyn Crescent to the next in Bodafon Street, then one is found in the grounds of Holy Trinity Church, another in Albert Street and the last in St David's Road. No further boundary markers are known, though those that remain clearly suggest the route it took. These insignificant-looking lumps of street furniture were once of great consequence for both rich and poor.

Although today the parish is of relatively little importance, in former times the situation was quite different. Since the medieval period, if individuals fell on hard times – the sick, the elderly, the infirm and orphans – relief could be claimed from their legal parish of settlement. All this was formalised in 1601 ('The Old Poor Law') and parish officials would collect a set amount of money from ratepayers to spend on poor relief. However, this system was essentially set up for those known as 'the deserving poor'. Others, 'the able-bodied poor' – those who had no money due to lack of work or because common land had been enclosed, for example – were considered a different category. Paupers travelling the country looking for employment were sent back to their home parish to claim relief. There are cases from across Britain of some of these unfortunates being whipped along the way.

As old boundaries became irrelevant in the early nineteenth century due to population growth and industrialisation, many were reorganised. In 1834, a new Poor Law was passed that saw the widespread introduction of the dreaded workhouse. Parishes were combined into a union: Llandudno and Eglwys Rhos became part of Conwy Union and a workhouse was later established in that town. After the Reform Act was implemented in 1837, the civil parishes of Llandudno and Eglwys Rhos remained separate and only in 1905 were they merged to become Llandudno cum Eglwys Rhos.

Parish boundary stone in Albert Street, 'LL P' facing in towards the parish of Llandudno.

Pen Dinas

From past millennia to relatively recently, agents such as coastal erosion and changes in sea level have eradicated many traces of Llandudno's earliest inhabitants. Other factors have also played a part, as is customary in an evolving landscape, for example agriculture, copper mining, quarrying and road building. Within the past 150 years the growth of the seaside resort and residential development has virtually eradicated anything previously on (or in) the ground. Notwithstanding these influences, Llandudno and its immediate hinterland retains a wealth of archaeological features. The Great Orme in particular has abundant signs of past activities, though many of these need a careful eye (and a good map) to distinguish from natural features. Some vestiges of earlier times only become visible through aerial photography, yet much remains on the ground for a more casual observer to appreciate.

Pen Dinas is one such example, overlooking Llandudno Bay from high above on the north-eastern flank of the Great Orme. It is generally regarded as being an Iron Age hill fort, dating from 600 BC to sometime early in the Roman period (after AD 77 in north Wales). Iron Age folk are considered to be the Celts who arrived in Britain from around 600 BC onwards, though this simplified picture has been modified by recent scholarship. Pen Dinas awaits a full archaeological examination but two partial excavations have yielded a number of small finds and have located an early phase of occupation, with indications of over fifty huts, and one later with six circular buildings. The Rocking Stone is situated towards the fort's southernmost corner. These all lie between the natural defences afforded by cliffs to the north and east and around the other sides by a large rampart, which is greatly degraded now – probably due to it being taken as building material for the new resort.

Foundations of a circular building, Pen Dinas.

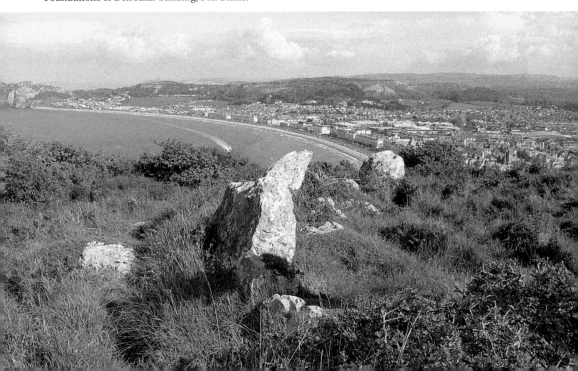

The Pier and Pleasure Steamers

Llandudno had been a recognised port of call for ships out of Liverpool on passage to Menai Bridge or Bangor since the 1820s. Over the next decades destinations such as Beaumaris and Caernarvon with their medieval castles increased in popularity and so, to a lesser extent, did the Great Orme. Passengers disembarking from wooden paddle steamers at Llandudno had to do so on to small boats and be ferried to the shore. Even here these smartly dressed visitors had sometimes to be carried on to dry land. It was not until 1858 that Llandudno had its first pier. This was largely destroyed in the great storm of October the following year and a somewhat sturdier structure resulted from its rebuilding. Unfortunately, although of adequate dimensions for the loading of quarry stone and other material onto small merchant vessels, both these early efforts did not reach out to sea far enough to enable larger boats to dock. The hazardous performance of moving between ship and shore continued.

As the years progressed other steamship companies joined this profitable tourist venture and more boats and routes were offered. It became apparent that Llandudno was losing business for even though the train had arrived here by 1858, cruising along the north Wales coast remained popular. Llandudno's new and much lengthier pier was completed in 1877 and sailing the seas, both to and from Liverpool and along the coast towards Caernarvon and excursions further afield to the Isle of Man, could be enjoyed without fear of being dropped in the briny ocean. The pier is the longest in Wales and is an attraction in itself, a wonderful place for a stroll and for taking in the sea air and views of the bay and along the coast. It is also an ideal location for observing many species of seabirds out to sea or flitting about the rocks and beach exposed at low tide. On a good day dolphins may also be seen.

Cruises remained popular well into the twentieth century. Around 1956 one vessel, *St Tudno*, employed a young steward plying the passage from Liverpool to Menai

Llandudno Pier.

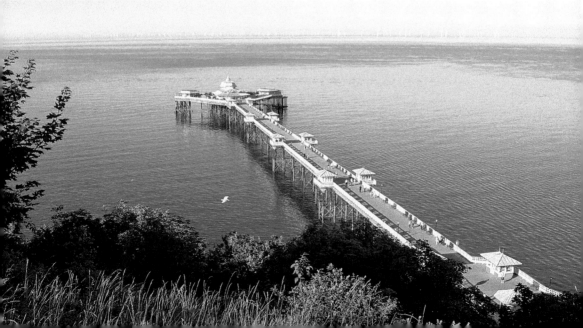

MV Balmoral passing the lighthouse – next stop, the pier, 2017.

Bridge who, seven years later, would return to Llandudno rather better known: Ringo Starr of Beatles fame. By then, in the early 1960s, tastes had changed and cruises were no longer profitable. They ceased operating as a frequent service by the late 1960s. In the last few years MV *Balmoral* has again offered occasional sailings from Llandudno and in the last week of August 2018 the paddle steamer *Waverley* is set to make two cruises from the pier to Anglesey.

The Promenade

The promenade nowadays allows for a fine and unimpeded walk along the sweep of the bay between the two Ormes. However, for the first couple of decades when it ran only as far as the short line of the first seafront hotels it was not always well-thought of. In photographs and engravings from the 1850s the promenade is shown as an area separated from a road of compacted ground by a low railing and running freely on to the beach. A commentator in 1863 complained of the 'miserable condition in which it is kept'. Visitors walking along it could not do so 'with any pleasure, or comfort' as this was 'not possible from the neglected and dilapidated state of the ground'. Ten years later another critic grumbled about its lack of lighting. Notwithstanding that the emerging town did not always get everything right first time, by 1861 the promenade was already becoming the focus for entertainments such as Wallace's Band. It was also the place to watch one of Llandudno's well-attended regattas. As the nineteenth century progressed the promenade's more positive aspects came to the fore and, along with the beach, was probably the resort's main attraction. By the 1870s it was especially favoured for an evening's promenading wearing ones finery, even if the music from the bandstand was not always to everyone's taste.

Richard Codman's Punch and Judy began to operate in Llandudno in 1860, though he had to move from the promenade on to Church Walks as the show aroused Lord

Mostyn's displeasure. After presenting the show to the Improvement Commissioners he was restored to his place on the promenade. Successive members of Richard's family have continued to captivate audiences with this traditional seaside entertainment and it remains a highly regarded feature of Llandudno's promenade. Often entertainments included several attractions and activities taking place at the same time. Summer firework displays were occasionally presented from the promenade and in 1876 this played out to music from a band 'in one place, a minstrel in other and a Punch and Judy performance, &c., took place elsewhere'. By the end of the century audiences were engrossed by further amusements, primary among these being Signor Gicianto Ferrari, *The Bird Man of Llandudno*, and his performing birds. A more sombre addition was Llandudno's war memorial, which was erected in 1922 to honour the town's fallen from the First World War.

As the years progressed the promenade was eventually made up in line with the roads in and around town. Trees and ornamental flowers were planted and seating was provided, all of which was modified and rearranged over time. The promenade continues to be one of the town's more popular amenities both for strolling along and for the events and attractions held along it, such as classic bike and car rallies, creative arts performances and many others. It is also a fine place for simply sitting and enjoying the view.

Codman's Punch
& Judy beguiling
all ages.

The rough-and-ready road and promenade, late 1850s, with the bathing machines' towels and bathing costumes for hire drying in the breeze.

Promenading near the war memorial.

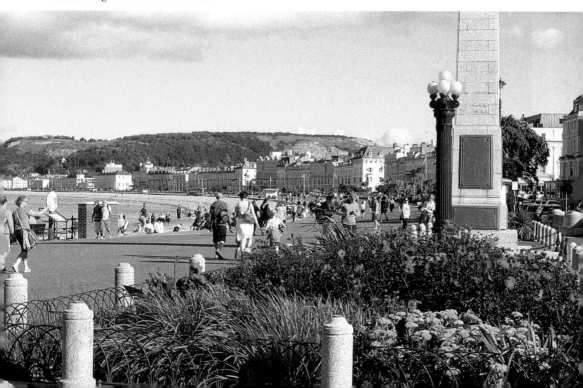

Q

The Queen of Romania at the Marine Hotel

The Adelphi Hotel, which was built by 1863, was added to Llandudno's seafront at a time when construction work in the new town was gathering pace. By 1890 it had become the Marine Hotel, the name by which it welcomed its most famous visitor on Tuesday 2 September of that year. Elisabeth, Queen of Romania, was greeted by hundreds of visitors and residents at the station when she arrived from Euston on a special train frequently used by the Prince of Wales (later Edward VII) and other members of the royal family.

Pauline Elisabeth Ottilie Luise zu Wied was born in 1843 in Neuwied, a small principality on the Rhine. In her childhood she was drawn to languages and writing. She wrote many works over her lifetime, those best known are under the pseudonym 'Carmen Sylva'. By the age of sixteen she was a prospective bride for the Prince of Wales, but she did not sufficiently please him. In 1861 she met Prince Karl of Hohenzollern-Sigmaringen in Berlin. She married the now Prince Carol of Romania (formerly spelt Roumania) in 1869 and in 1881 they were crowned king and queen. Their only child, Maria, died aged three of scarlet fever, a disease that knew no social barriers.

Llandudno was not the first choice destination in 1890. During the last week of August her attendant visited the Queen's Hotel in Aberystwyth with a view to her staying there on the 'orders of her physicians to visit Wales'. At least, that was the official version. Her husband had adopted his nephew Ferdinand as his heir. Unfortunately, Ferdinand became somewhat friendly with Elena Văcărescu, one of Elisabeth's ladies in waiting. Elisabeth fostered this illicit affair, which was prohibited under the Romanian constitution. It appears that she and Elena were given instructions to tour Europe until they had found a suitable bride for Ferdinand. Their search ended when they met Queen Victoria's granddaughter, Princess Marie of Edinburgh.

Aberystwyth that August week was felt inadequate for Elisabeth's needs, so apartments in the Marine Hotel were speedily arranged and elaborate preparations made for her arrival. Initially she was not impressed with the town and its throng of tourists, though during the time she spent here she grew to enjoy her stay and readily immersed herself in local affairs, both with local nobility and, perhaps unusually for the time, with those further down the social scale. In her private diary she had expressed the view that republicanism, not royalty, should be the preferred form of government. Concerts and other spectacles were given in her honour. The queen travelled widely across the region to Conwy, Caernarvon, Anglesey, and, accompanied by Lord and

The Marine Hotel.

Inset: Queen Elisabeth, 'Carmen Sylva'.

Lady Mostyn, to the Eisteddfod in Bangor where she presented the Chair to Reverend Thomas Tudno Jones of Llandudno. After a short visit to Ireland she departed from Llandudno on 1 October and travelled to Balmoral where she visited Queen Victoria.

The Queen of Romania's visit to north Wales was a resounding success. Though Llandudno had previously played host to royalty, her stay was met with celebration. The local press, both Welsh and English language versions, made much of her visit. It was something of a coup that this resort had been chosen for her sojourn and furthered a particular identity for the town. Elisabeth of Romania is commemorated in the names of Carmen Sylva Road, Roumania Crescent and Roumania Drive and others. On her last day in Llandudno she expressed the view that north Wales was 'a beautiful haven of peace'. Translated into Welsh this becomes '*Hardd, Hafan, Hedd*' which was adopted as Llandudno's motto.

Questionable Postcards

The majority of postcards are of views and scenery. A smaller number are 'saucy'. Some are simply downright questionable. The two presented here belong in the latter category. The first, with its scenes of brawling and undue attention being paid to a young lady lately arrived by train, is perhaps not a good advertisement for this or any other town's charms. The second showing the arrival of the 'honeymooners' was rather worryingly issued for Llandudno only and we must assume that the grandees of this esteemed resort instructed their solicitor to write a strongly worded letter of complaint.

Posted in 1908.

Posted in 1909.

Randy's Bar

At the boxing match in Earl's Court on 10 July 1951 for the World Middleweight title, British boxer Randolph Turpin defeated on points Sugar Ray Robinson of the USA. Turpin immediately became a hero in boxing circles and for the British public at large. The rematch took place in New York just two months later and resulted in victory, this time for Robinson, when the referee stopped the fight in round ten.

Robinson had retired from boxing by the time Turpin fought again for the World Middleweight title. This contest against French opponent Charles Humez in London's White City Stadium on 9 June 1953 brought about not just a front page report in the *Daily Mirror* but something of an incongruous headline. The fight was held in London's White City Stadium between Randolph Turpin and French opponent

The Summit Complex.

Inset: The front page of the *Daily Mirror*, 10 June 1953. (Courtesy of Charles Eaves and ©Trinity Mirror Publishing Ltd)

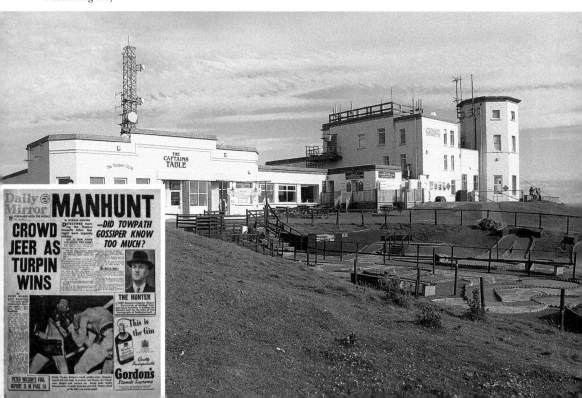

Charles Humez. Turpin won the fight on points after fifteen rounds and with it the title, yet the *Mirror*'s sports reporter Peter Wilson was scathing about Turpin's performance. According to Wilson, Turpin made Humez 'look a flat-footed clown' as he cleverly out-boxed him, yet the spectators were unforgiving – Turpin had lost the 'dynamite hitting' and 'controlled ferocity' that had become his trademark. They had hoped to witness the Frenchman on the receiving end of a battering and finally succumb to a knock-out blow. When it had not ensued by round twelve, slow handclapping began. This was soon followed by jeers and boos.

Randolph Turpin hailed from Leamington Spa, where he took up boxing at an early age. On retirement in 1962 he left the boxing ring with a record of sixty-six wins (forty-eight by knockout), eight losses and one draw. His association with Llandudno began in 1952 when he and Leslie Salts bought and became registered licensees of the Summit Complex on the Great Orme. Randy's Bar was soon attracting many visitors and he would hold sparring matches in the grounds. It has been reported that he could not come to terms with the relative obscurity following the rematch defeat by Sugar Ray Robinson and by 1961 had lost his bar and been declared bankrupt. Sadly, he committed suicide in 1966. His memory lives on in Llandudno and his bar in the Summit Complex has been renovated and exhibits many photographs and memorabilia from his days as boxing champion.

The Rocking Stone

A rectangular stone around 6 foot long by 2 foot high and broad lies above the town on the Great Orme, adjacent to the hut circles of Pen Dinas hill fort. It is known by two names, 'Maen Sigl' (Rocking Stone) and 'Cryd Tudno' (Tudno's Cradle). Some suggest it is an ancient monument with connections deep in the past, others that it is a natural peculiarity. As may happen with ambiguous features in the landscape it is swathed in legend. One story has it that local Druids used it to prove the guilt or innocence of those accused of a terrible crime. The suspect stood on the stone and if they were able to make it rock they were innocent and released; the wretches for whom the stone stood resolutely still found themselves immediately guilty and thrown off the cliff. (Author's note: I'm worried. I couldn't budge the thing.) Another tale maintains that in the seventeenth century mothers who wanted their babies to learn to walk quickly would place them on the ground and have them crawl around the stone three times, once a week. Some folk tales can contain an element of truth or an echo of past traditions, though it is often difficult to disentangle this from tales heard from 'a man in the pub'. Whatever the nature or history of the stone, from its vantage point glorious views across Llandudno and both its bays and beyond are presented. Kashmiri goats may come and join us as we sit inside this ancient settlement, as might small and secretive birds and, in summer, scarce butterflies, settling on the flowers close by.

For myself, I'm relieved to say a report has been written that states the stone no longer rocks because of the misdeeds of the town's youth, those we see 'exhibiting their graces on the Esplanade'. These 'fast young "gents"' have deliberately thrown the stone off its balance. At least, that was the opinion of a visitor in 1868 for whom the stone had apparently rocked when he had been there ten years previously.

The Rocking Stone and West Shore.

S

The Sea, Regattas and Llandudno Sailing Club

Llandudno's relationship with the sea stretches back thousands of years. This long association is likely to have promoted folkloric customs and practice, of which regattas appear to have played a part. To celebrate the coming of age of Thomas Edward Mostyn Lloyd-Mostyn in January 1851 a parade headed by a 'Band of Music' and 'Seven Fat Oxen and Twenty-Eight Fat Sheep for the Poor' travelled through seven parishes, starting from Llandudno to Llanrhos, where it was joined by a large procession that went on to Gloddaeth Hall, thence to Bodysgallen Hall and finally Conwy before departing for their home parishes. The next day the animals were distributed to the poor. This was followed at Llandudno by 'rustic amusements and a Regatta'. On the third day of festivities 'Poor Men' were given 'dinners', though 'Poor Ladies' had to be content with 'tea'. This celebration resounds with echoes of an ancient tradition.

With the development of the tourist industry in the mid-1850s local boatmen were not slow in offering trips around the bay and regattas became popular events. The one of September 1861 attracted 'several thousands' to watch a race between the Ormes for nine boats 'in full sail'. Even allowing for journalistic exaggeration this seems to have been a well-attended occasion. Regattas began to embrace many classes of boat, both those powered by the wind and those by oarsmen and that of August 1868 also included a 'grand procession of illuminated boats', choral singing, bands playing and a firework display. Swimming races and 'walking a greasy pole' were contested in the regatta that was part of the Lifeboat Fête in 1891.

Llandudno Sailing Club was formed in 1895 and the 'Easter attractions' of that year 'were supplemented by a sailing boat race' promoted by the club. A football match was played between Llandudno Swifts and Everton Combination and concerts were given at Rivière's Concert Hall and at the Pier Pavilion. Apparently, around 8,000 people were estimated to have arrived by train for these attractions, while the steamships *St Tudno* and *Snowdon* brought 700 and 500 passengers, respectively. The club prospered for a number of years until two events saw its demise. The first of these was a major storm in 1907, which wrecked many of the boats. The second was the outbreak of the First World War. By 1963 local enthusiasts had revived the club and in 1968 the present clubhouse alongside Venue Cymru had opened. The waters of Llandudno Bay and the town's sailing club soon became a setting for national championships. The club has gained an excellent reputation for the dinghy sailing classes it offers and has been awarded the Recognised Training Centre status by the Royal Yachting Association (RYA). Indeed, its rise has been such that for many years

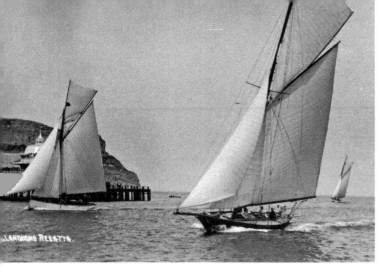

Llandudno regatta passing the pier, possibly 1920s.

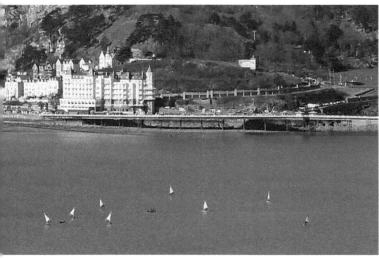

An early spring race.

it has supplied officials for major sailing events around the country – and further afield, for at the Athens Olympic Games in 2004 the current president Tony Lockett was appointed chief race officer. The club's own domestic racing programme begins at the end of March and continues to the end of November, much, no doubt, to the continuing delight of onlookers from the promenade and pier.

St Tudno's Church

At the beginning of the fifth century the last of the Romans departed from Britain. The core of the empire was under threat from 'barbarian' invaders. It was to no avail, however, for in AD 410 Rome was sacked by the first wave of pagan Germanic peoples. Within a few decades it would be despoiled more than once and eventually succumbed to anointing Germans as emperor. The Western Roman Empire fragmented and ceased to exist and western Europe entered a 'Dark Age'. Britain did not escape, seaborne Germanic folk – Angles, Saxons and Jutes – overran the south-east and advanced over what is now England. It was in these areas that an 'English' language and culture came to dominate. Cities were forsaken and literacy became a thing of the past: the veneer of Romanisation was abandoned. It became

a time of myths and legends. Centuries later writers would begin certain narratives of these days with phrases such as 'according to tradition'.

In this confusion, which rapidly degenerated into petty kingdoms incessantly at war with each other, there was but one common element: the Church. In Ireland, which was never part of the Roman Empire, a Celtic vision of Christianity had arisen and the western sea routes that had been a main highway since the Stone Age again came to the fore. Sometimes of obscure pedigree and sometimes from fabled backgrounds, emerged those Christian ascetics and missionaries who would be canonised centuries later. According to tradition the Great Orme became a hermit's refuge in the sixth century; his name was Tudno.

Nothing remains of any building that might have existed in St Tudno's day, nor from the following centuries. Archaeological excavation has located indications of postholes, though these are undated. The present church has its origins in the twelfth or thirteenth centuries and part of the north wall may be from this period, though its basic fabric dates to the years around 1500. A nineteenth-century view of the church appears to show crop marks and the foundations of a small building (at the bottom left) on the site where the new cemetery would lay in 1903, suggesting that this place of worship was not always isolated. A violent storm in 1839 severely damaged the building, blowing off most of the roof. By then attendances in this now remote spot had been falling for some time. The decision was made to build a new church closer to the town centre: St George's on Church Walks was completed in 1840. St Tudno's then stood in windswept desolation and ruin until it was restored at the expense of William Henry Reece from Birmingham, reopening in October 1855. The restoration encompassed replacing the former square east window with one in the Decorated style and rebuilding the roof, though some of the former structure was retained. Internally there are a number of interesting features including the font, which dates to the twelfth or thirteenth century (the pedestal is modern), and two medieval grave

Is this evidence of early – possibly medieval – ploughed ground and buildings close to the church?

Inset: St Tudno's Church in 1859, showing the new east window.

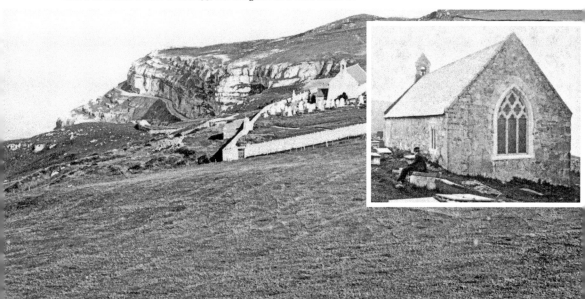

St Tudno's Church and outdoor pulpit.

slabs built into the south-west wall of the nave. Outdoor services are recorded by 1857; after completion in 1912 the outdoor pulpit became an additional focus for Christian ceremony. Services continue to be held at this little church in its dramatic setting overlooking the sea, a holy place whose origins lie lost in the dark mists of time.

Street Furniture

Street furniture – traffic lights, road signs, bollards, litter bins etc. – can often be the bane of the urban photographer's existence. It is not unknown for photographs of fine-looking buildings to seem more like a montage of 'Give Way', 'No Entry' and 'Reduce Speed Now' directives. Fortunately, some of the structures adorning Llandudno's streets are attractive and of historic value, such as the ancient parish boundary stones that run through town.

The first pillar boxes in which to post mail – rather than hand it directly to the postmaster – appeared in 1853, becoming standardised by 1861. A design that soon followed was by J. W. Penfold in 1865. A rare survival of one of his hexagonal cast-iron pillar boxes is located outside Queen's Hotel on St George's Crescent, opposite the promenade, and continues in use today. Philatelists can but dream of the letters and cards posted here over the last 150 years or so, especially those bearing scarce stamps.

Over the last couple of years a number of large statues of characters from *Alice's Adventures in Wonderland* and *Through the Looking-Glass and What Alice Found*

There have been placed around town, commemorating Alice Liddell's connection with Llandudno. The Mad Hatter sits on the promenade behind the Penfold pillar box.

Llandudno can boast of a number of original nineteenth-century lamp standards (streetlights), though the most majestic of all has to be the late Victorian example situated at the bottom of Happy Valley. As odd as it might sound, it, like the Penfold pillar box, is a Grade II-listed building.

Not all street furniture rests at ground level, however; for example, an ornate wrought-iron bracket attached to the upper wall of No. 86 Mostyn Street supports a circular clock with two faces. This building is one of a group dating to the 1860s that are also Grade II listed. Further examples of a different kind of 'off the ground' street attractions are red commemorative plaques adjoining many a wall. These indicate a building or area associated with well-known locals and visitors – such as the one near the original entrance to the pier honouring world famous conductor Sir Malcolm Sargent, who spent two seasons from 1926 as conductor of the orchestra at the Pier Pavilion. An earlier conductor of the Pavilion Orchestra, Jules Rivière, is remembered with a plaque borne on the street side of the boundary wall of his former house 'Bôd Alaw' ('The Abode of Melody') in Church Walks. They add fascinating information to a walk around town. They also augment, rather than detract from, urban photographs.

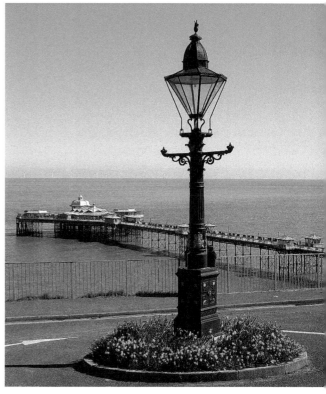

Above left: Penfold pillar box from *c.* 1865 on St George's Crescent with the Mad Hatter on the promenade.

Above right: Victorian lamp standard, Happy Valley.

T

Tombolo

In the not-so-distant geological past the Great Orme was an island. Now a wide expanse of low-lying land extends between the Ormes and down the Conwy valley at West Shore. The isthmus on which Llandudno stands is recognised as one of the finest examples of a 'tombolo' in the country. This feature is a strip of land that usually develops between the mainland and a nearby island. They take shape when sea currents are slowed down, lose energy, and deposit sediments in the sheltered and shallow waters found around islands. A spit composed of clays and sands gradually builds up until island and mainland are joined. For Llandudno, this material was most likely supplied by the River Conwy flowing through its new estuary (it once flowed through Llandrillo and entered the ocean near Rhos-on-Sea), by longshore drift of sand along the coast from Penmaenmawr and from reworked earlier glacial debris. Before the building of the resort – whose very existence is owed to this tombolo – the isthmus was primarily a land of sand dunes and salt marshes. Little of this remains visible except at the Conwy end of West Shore, where remnants of sand dunes can still be found, although these are but a pale imitation of what covered this area of ground only a few decades ago.

West Shore at low tide with sand spit and a small (dark) patch of stabilised sand dunes.

Inset: Dunes in their 'raw state', c. 1910.

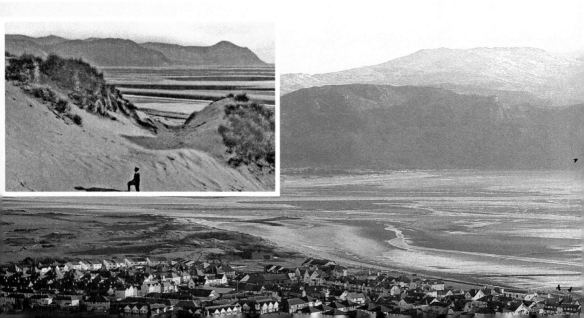

The Town Hall

Llandudno's Town Hall in Lloyd Street was completed by 1902 and is representative of a new wave of architecture appearing in town around that period. However, had Llandudno's Board of Improvement Commissioners acted in a more timely manner the building's design would have been likely to mirror that of the hotels being erected on the seafront in the 1850s. The commissioners conducted their business from an office on Church Walks – this building is now the Capri Guest House. They were aware in 1853 that Llandudno needed an administrative centre in keeping with the plans and aspirations they had for the new resort. In that year it was proposed 'to construct, regulate, and maintain, a Town Hall, with assembly, news, and other rooms, for the use of the inhabitants'. Such a resolution was passed decade after decade without a great deal being accomplished and it was only in 1894 that Lord Mostyn gave a plot of land on Lloyd Street as the site for the proposed municipal building. As was common at the time, a competition was held where various proposals were considered. The winning design was submitted by T. B. Silcox from Bath and work on Llandudno's new Town Hall commenced in October 1899. By then the Board of Improvement Commissioners were no more, having been superseded by Llandudno Urban District Council.

The building is an example of neo-baroque architecture, which, as an architectural fashion, grew out of Victorianism whereby new construction techniques and materials were wedded to a deference to tradition. Llandudno's Town Hall has a distantly related antecedent in St Paul's Cathedral in London, designed by Christopher Wren in the late seventeenth century. A closer family member, also constructed using a facing of red brick and white stone, was Chelsea Town Hall, built in 1885–87. During the years of the Second World War Llandudno Town Hall's large internal rooms were the ideal venue for distributing gas masks to the town's citizens – just one of its functions during those years. It is now the centre of administration for Llandudno Town Council.

The first wave of architectural fashion, as revealed by Queen's Hotel, *c.* 1856.

The second wave, Llandudno Town Hall.

Traffic Jam on the Great Orme

'Now, just where is that tasty bit of vegetation we need to keep in check on this beautiful summer's day? I think I'll follow the one leading the way until we get there. Tram? What tram?' The Great Orme's flock of 400 or so sheep superbly assist in maintaining this finely balanced ecosystem and they know their place in the grand scheme of things. This individual nonchalantly crossing the road has no interest in the unique tram system, nor that cars on their way to the summit are approaching a very steep stretch of Tŷ Gwyn Road in front of Belle Vue Terrace – this is open countryside and her home, and in her mind we are merely guests.

Sheep sensibly passing under an appropriate road sign as they bring traffic to a halt.

U

Up, Above

When walking along a street pavement in the centre of town we watch where we are going, avoiding obstacles and wayward pedestrians, maybe on the lookout for a particular retail outlet and occasionally being distracted by shop window displays. Rarely do many of us look up, above the ground floor to the higher levels of buildings. By doing this local architecture worthy of a second glance may sometimes go unobserved. To illustrate this, three examples of 'up, above' from Llandudno's main streets.

Lower Mostyn Street, above 'Pebble, licensed fish restaurant'.

Above: Corner of
Vaughan Street and
Oxford Road, above
'Clintonjames'.

Left: Detail on
the Palladium,
Gloddaeth Street.

Llandudno's Urbane Visitors

Before the invention of photography portrait paintings had for centuries captured an image of individuals for posterity, but this way of being remembered could only be achieved by the wealthy. Early photography was also an expensive process. We may sometimes catch sight of the less well-off towards the end of the nineteenth century as postcards became popular, though any people in them were usually just part of the scenery. The early 1850s witnessed the development of the standard sized carte de visite (CDV), a more robust photograph than earlier types and one cheaper and easier to produce. Llandudno's photographers quickly caught on to the possibilities of this new invention – as befitted a new tourist enterprise trying to make its mark on the world, a destination that catered for the burgeoning middle classes, a group who could afford these luxury items. Over the years the town could boast ten or more photographers offering the service of supplying these urbane visitors with a CDV to take home for the family album. CDVs are thus a wonderful treasure store for allowing us a glimpse of Llandudno's early guests, people who are rarely depicted elsewhere.

Unfortunately it is usually difficult to put a name to a face – the CDV of bonnet-wearing Aunty Nell Pugh being an exception. It is even less common to discover a person we can trace through other sources: Cambridge-educated Reverend Mountford Wood (1811–89) was first curate, then rector, of the parish church of Aldbury, Hertfordshire. As they are relatively common, CDVs are helpful for illustrating fashions in dress, jewellery and hairstyles of the town's visitors. The bustle was all the rage around the mid-1870s when this lady's photograph was taken. Hair more informally tied back – as the unmarried young lady has – became more popular as the century progressed. As for connecting us in imagination with the past, we might consider the CDV of the elderly chap. If this image is correctly dated to around 1865 and we assume he was seventy years of age, then he was born around 1795. This unknown visitor to Llandudno whose photographic likeness we may still gaze upon would have been around ten years old when Lord Nelson contested the Battle of Trafalgar (1805) and twenty when the Duke of Wellington fought at the Battle of Waterloo (1815). We can only guess at what his opinion of Napoleon might have been.

Five of Llandudno's urbane visitors in the nineteenth century, as depicted on CDVs.

V

Vernacular

On first hearing the often-used phrase 'Bog Island' it is tempting to believe that the junction where Mostyn Street meets Vaughan Street was once marshland with a patch of drier ground rising from it. It may have been soggy terrain once, but the phrase, perhaps regrettably, is local vernacular for the circumstance that this is the site of a very longstanding public convenience in North Western Gardens.

Conveniently situated at one corner of North Western Gardens.

The Victorian Extravaganza and Llandudno Transport Festival

Changes in how and where holidays were taken – driven by increasingly less expensive air fares – created unfortunate consequences for all British seaside resorts by the 1980s. Llandudno had to adapt and a number of new ideas were put forward. One of these was proposed in 1986 by Mayor Cllr Margaret Lyons and a small group of councillors: that the town should host a Victorian Extravaganza on the weekend of the first bank holiday in May. This was an instant hit and has been held every year since then. Perhaps the most innovative feature is to stage the event on the town's main streets, which are closed off to traffic, thereby allowing for free access to sideshows, the funfair, street theatre, parades (including local enthusiasts dressing up as Victorians) and all the other elements that make this event an 'extravaganza'.

Over the years the management of the event slowly changed – it is now run by Llandudno Victorian Extravaganza Ltd – as did aspects of what was presented to the public. In the early days vintage car and motorbike rallies were held. As the financial situation of the Extravaganza became gradually reorganised an additional event was introduced at Bodafon Fields, which by asking for an entry fee could supplement the Extravaganza as a whole. It was developed by local transport aficionados and now has a life of its own as the Llandudno Transport Festival and takes place on the same days as the Extravaganza. It has become the largest transport festival in Wales and features a fascinating array of vehicles from all periods – motorbikes, cars, commercial vehicles, buses, tractors, steam engines large and small and occasionally trams – both on the field and, where allowed, in town itself. The field also hosts many stalls selling a diverse range of goods, not solely transport related, such as antiques. There are now over 1,000 exhibits shown at the festival and exhibitors, many of whom have become regulars, arrive from all over Britain.

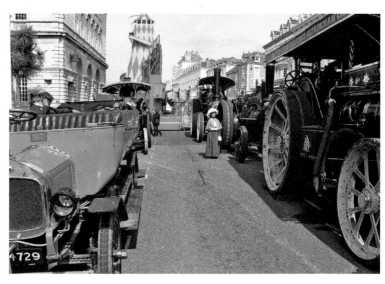

After the Extravaganza parade in 2017 m'lady inspected the steam engines and charabancs.

Wearing One's Sunday Best

In recent times the prevailing trend has been to dress down when on holiday, to wear clothes to relax in and maybe catch the sun. For at least 100 years the fashion was quite different: one wore one's Sunday best on holiday, even for lounging about on the beach. A trip to Llandudno was a fine opportunity to leave everyday clothes at home and stroll along North Parade and the promenade in one's finery – often heavy and baggy clothing exposing a minimum amount of skin and always seemingly topped off with a bewildering array of hats and bonnets.

Holidays were perceived differently than they are today. Before, say, 1850 travelling to far-off destinations for entertainment or to explore new places was an activity enjoyed by only the rich who had the available time and resources. With the rise of the industrial age in the early 1800s came the growth and development of mass-employment complexes such as factories and offices. By the 1840s the railway network was quickly spreading across the land. Industrial workers needed a break from their tiresome work, the railway executives recognised a new market emerging and seaside destinations took on new roles and expanded to accommodate the increasing number of visitors arriving by train to enjoy their week or two in the sun. The resort of Llandudno was brought into being and fashioned likewise. These visitors brought with them the social habits of their time, which included wearing one's Sunday best when one went somewhere special.

Beachwear, North Shore, 1907.

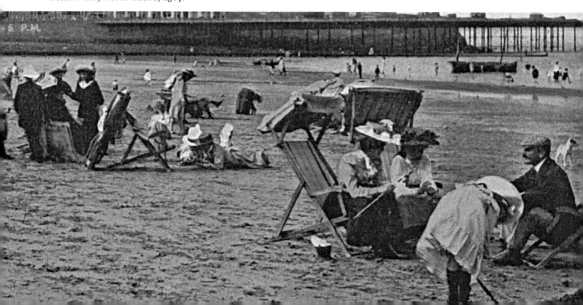

West Shore

The long sweep of West Shore lies on Conwy Bay. In plans and drawings of 'the Llandudno to be' from the early 1850s the area seems to be a minor inconvenience. The present-day shortest route between North and West Shores is along Gloddaeth Street. In the early engravings this distance is shown less than half its true length. Photographs from the beginning of the twentieth century show the Model Yacht Pond and a scattering of buildings inland. Some of these were guest houses though the majority were residential properties and it is as such that the area developed as the century progressed. Although not as famous as North Shore, West Shore has its own history.

The area's most celebrated residents were here in the early 1860s: Henry George Liddell, Dean of Christchurch, Oxford, and his family. In August 1862 his grand house Penmorfa had been completed at the Great Orme end of the bay. His daughter Alice was later to be cast as the heroine of Lewis Carroll's *Alice's Adventures in Wonderland* and *Through the Looking-Glass and What Alice Found There*. She spent many holidays here until their last in 1871 and had a strong association with the town, though there is much dispute as to whether Charles Dodgson (Lewis Carroll's real name) actually came here. Alice's stays at Penmorfa are commemorated with a statute of the White Rabbit, unveiled by David Lloyd George in 1933. Recently, other statues of characters from the books have decorated Llandudno's streets. The house was later extended to become Gogarth Abbey Hotel. In the Second World War it was used as the headquarters for senior staff from the Artillery School on the Great Orme.

West Shore, towards the Great Orme.

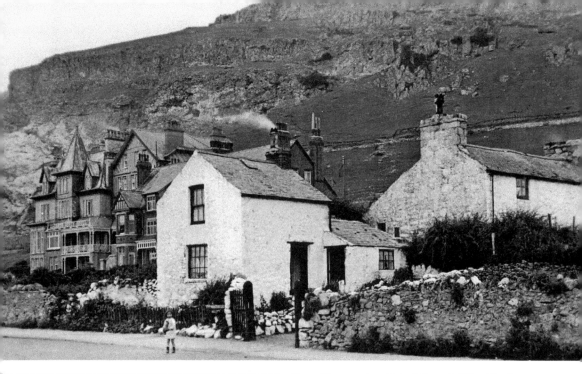

Above: The now demolished Gogarth Abbey Hotel, formerly Penmorfa, with miners' cottages, postcard dated 1917.

Left: The White Rabbit statue, 1933.

This area had witnessed a major engineering project some thirty or so years before being discovered by Dean Liddell. So as to contain flooding in the lower levels of the copper mines operating high above on the Orme, Penmorfa adit was driven 882 metres into the headland. This was achieved by miners working shifts night and day from 1834 to 1842, descending to a depth of 215 metres below the surface, some 70 metres below sea level.

From 1907 to 1956 the building next to the White Rabbit statue was the terminus for the Llandudno & Colwyn Bay Electric Railway. This listed building is just about all that remains visible today of this once popular tram service. For the last ten years its route along Gloddaeth Street to North Shore has been followed by Llandudno's Italian-made Land Train.

Right: Terminus of the Llandudno & Colwyn Bay Electric Railway.

Below: The Land Train in Gloddaeth Street, on its way to West Shore.

X

Sending a Kiss from Llandudno

The writing of 'x' as shorthand for 'kiss' may be traced back to a letter sent by British curate and naturalist Gilbert White in 1763, although recent research suggests that it is a late nineteenth-century invention. Whether the letter represents the coming together of two sets of pursed lips is open to debate. Postcards, with their limited space for writing, were an obvious candidate for 'x' at the end of correspondence between those who were romantically inclined and for sending to family members. Examples of its use can be found on cards sent from Llandudno around the turn of the century and into Edwardian times, but they are not common. By the 1920s it had become well established. This card, posted in 1926, ends with the rather touching 'xx Ma xx', sending kisses to Jack. Many thousands of kisses have been sent from Llandudno to loved ones since those days.

"I WAS TOLD TO LOOK FOR A BUS WITH A W ON THE FRONT!"
"NO, THIS ISN'T IT, MISSUS, WE'RE NOT SO ACCOMMODATING!"

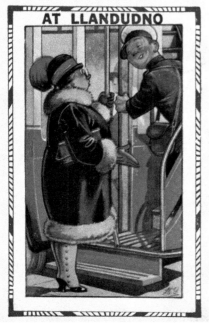

AT LLANDUDNO

Sent to Jack from Llandudno in 1926, from Ma, with four kisses.

Y

The Model Yacht Lake

As the setting out and building on land around West Shore was not subject to the same constraints as that along North Shore, novel features could be introduced. A model yacht club had been one of the town's societies for a number of years by 1896 when the Model Yacht Lake opened above West Shore's beach. In that year Ben Williams, secretary to Llandudno Sailing Club, remarked that the sailing club had developed from the model yacht club and that most members belonged to both – assembling toy boats had progressed to building and racing full-sized sailing craft. Today's scaled-down vessels on the lake are more likely to be radio-controlled and powered by electricity rather than sail.

From late spring to early autumn this expanse of water is also an opportune place for swans and other aquatic birds to potter about on. In the rest of the year, when not drained for maintenance purposes, it is favoured by seagulls.

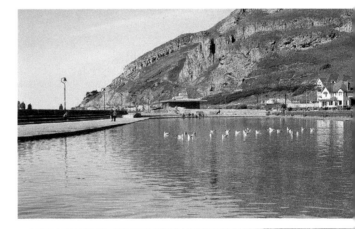

Springtime, before the arrival of swans and small boats.

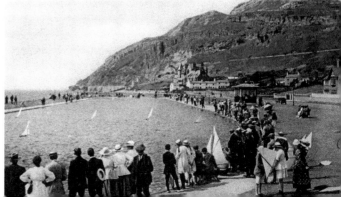

Model Yacht Pond, 1919, with Gogarth Abbey Hotel in the background.

Zag and Zig – and Plum Line

The crags and cliffs of the Great and Little Ormes offer nesting sites for seabirds, are home to a fascinating range of small plants and are wonderful scenery for the rest of us. For one adventurous group they also present a challenge: rock climbers. The limestone Ormes have been known for many years to offer steep, exciting climbs, yet also provide different types and grades of ascents to suit a range of skills and experience. The most difficult and longest routes are found on the Little Orme, while those on the Great Orme tend to be gentler – though 'gentler' for non-climbers is likely to be a relative term.

As a route up a cliff face is conquered it is given a name. Many of these are quite descriptive, and sometimes rather poetic. On the Little Orme climbs can be found known as 'Hydrofoil', 'Auks' Route', 'Shazam', 'Quietus' and 'Midnight Blues'. The Great Orme offers 'Oyster', 'Mayfair', Beachcomber', 'Plum Line' and 'Zag' and 'Zig'. The last three of these are visible from the north-western facing side of the pier – on the headland Pen Trwyn, which majestically projects out into sea. '*Pen*' is Welsh for 'Head (land)' and '*Trwyn*' is 'Nose'. There is no doubt this promontory is aptly named.

Towards the end of the headland, above the course of Marine Drive, a left-facing near-vertical groove is clearly observed: this is Zag. Plum Line begins ten feet to the left of Zag and Zig a little further along. All three climbs grade as very to extremely severe. At the summit glorious views along the coast are presented, views that are also accessible for those of us who go by less exciting routes.

The climb Zag ascends the leftwards-facing near-vertical groove towards the end of the headland.

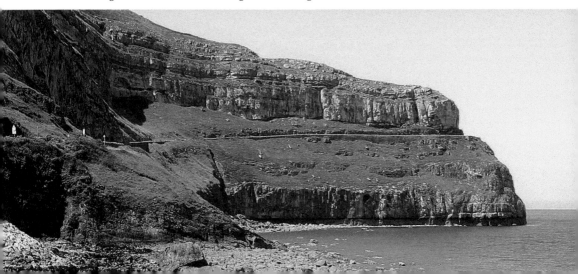

Select Bibliography

For an overview of the area:

Johnson, P. & Jefferis, C., *Conwy & Around in 50 Buildings* (Stroud: Amberley Publishing, 2016).

Johnson, P. & Jefferis, C., *Conwy & District Pubs* (Stroud: Amberley Publishing, 2016).

For Llandudno before 1850:

Great Orme Bronze Age Mines (nd) Great Orme Mines Ltd, Llandudno.

Aris, M., *Historic Landscapes of the Great Orme* (Carreg Gwalch: Llanrwst, 1996).

Bannerman, D. and Bannerman, N., *The Great Orme Explained* (Campbell Bannerman Publications: Llandudno, 2001).

Draper, C., *Llandudno Before the Hotels* (Llygad Gwalch: Pwllheli, 2007).

For Llandudno's streets and modern guides to walks in town and hereabouts:

Draper, C., *Walks from Llandudno* (Carreg Gwalch: Llanrwst, 2010).

Evans, P. C., *Streets of Llandudno* (Llandudno Historical Society: 2001).

Lawson-Reay, J., *Llandudno History Tour* (Stroud: Amberley Publishing, 2015).

Recent publications:

Johnson, P., *Llandudno at Work* (Stroud: Amberley Publishing, 2018) – the companion volume to *A–Z of Llandudno*.

Lawson-Reay, J., *Secret Llandudno* (Stroud: Amberley Publishing, 2017).

About the Author

Peter has a background in academic research and was a part-time university lecturer. He is a Fellow of the Royal Numismatic Society and has published a number of papers in this field; in his latest he confirmed the existence of an ancient Greek town previously lost to history. Peter recently gained the Advanced Diploma in Local History at the University of Oxford. In addition, he has been a keen writer of fiction for many years, winning a number of competitions.

Acknowledgements and grateful thanks to:
Dr Steve Baker from the Labologist's Society
Michelle Brown at UK Rock Heaven
James Burns and St George's Hotel
Charles Eaves at All Our Yesterdays, Colwyn Bay
Philip Evans and Llandudno Museum
Valerie Hailwood (and Hanni and Izzie)
Adrian Hughes at the Home Front Museum
Alun Pari Huws and the Royal National Lifeboat Institution, Llandudno
Christine Jones and St Tudno's Church
Nick Jowett and the Great Orme Bronze Age Mines
Kirsten Kite
Tony Lockett and Ruth Brown at Llandudno Sailing Club
Sam Williams of Llandudno FC
Library of Congress, Washington DC, USA
The National Portrait Gallery, London
Trinity Mirror Publishing Ltd
Venue Cymru